CELESTIAL WATERCOLOR

CELESTIAL WATERCOLOR

LEARN TO PAINT THE ZODIAC CONSTELLATIONS AND SEASONAL NIGHT SKIES

Elise Mahan with D.R. McElroy

ROCK
POINT

Brimming with creative inspiration, how-to projects, and useful information to enrich your everyday life, Quarto Knows is a favorite destination for those pursuing their interests and passions. Visit our site and dig deeper with our books into your area of interest: Quarto Creates, Quarto Cooks, Quarto Homes, Quarto Lives, Quarto Drives, Quarto Explores, Quarto Gifts, or Quarto Kids.

First published in 2019 by Rock Point,
an imprint of The Quarto Group
142 West 36th Street, 4th Floor
New York, NY 10018 USA
T (212) 779-4972 F (212) 779-6058
www.QuartoKnows.com

Rock Point titles are also available at discount for retail, wholesale, promotional, and bulk purchase. For details, contact the Special Sales Manager by email at specialsales@quarto.com or by mail at The Quarto Group, Attn: Special Sales Manager, 100 Cummings Center Suite 265D, Beverly, MA 01915 USA.

10 9 8 7 6 5 4 3 2 1

ISBN: 978-1-63106-588-0

Editorial Director: Rage Kindelsperger
Managing Editor: Cara Donaldson
Senior Editor: John Foster
Art Director: Cindy Samargia Laun
Interior Design: Merideth Harte

Printed in China

CONTENTS

Introduction

I grew up in the lush and verdant forests of Northern California in a family of artists, musicians, and writers. My love for art and nature began there among the starry nights and majestic redwood trees that towered above the place we called home. They stood as a constant reminder of the beauty and power of the natural world and served as a source of reflection for me.

Even as a child I was always making artwork influenced by my adoration of nature. I could often be found working in my sketchbook, making still-life drawings using the flowers and botanical elements I found growing on our land. Some of my favorite childhood memories were the nights my family would gather our coziest blankets and lay them in the field near our home to stargaze. We would listen to the sound of the wind move through the trees, make up new constellations, learn about ancient ones, and sing songs about the moon. The wild environment, along with those starry nights, always remain with me as my muse as well as a source of inspiration when I paint.

I studied art history in college, where most of my classes were focused on learning the names of artists and writing long essays about them. As much as I adore art history and am constantly inspired by the artists I learn about, I found myself drawn to *creating* art rather than writing about it. I work with watercolor because I love the layered quality it gives my paintings; their range of colors; their quick-drying nature; and the fact that it is possible to purchase nontoxic watercolors, which helps a great deal because I share my studio with a curious two-year-old who constantly wants to explore all of my art materials.

In this book you can find a guide to the various techniques I use to create my celestial paintings, as well as my preferred art materials and my artistic process. You may use this book to create your own sky inspired by the four seasons, learn about the constellations and astrological signs, and practice different techniques to achieve a luminous moon painting. Thank you for looking and I hope you enjoy my celestial corner of the universe.

–Elise Mahan

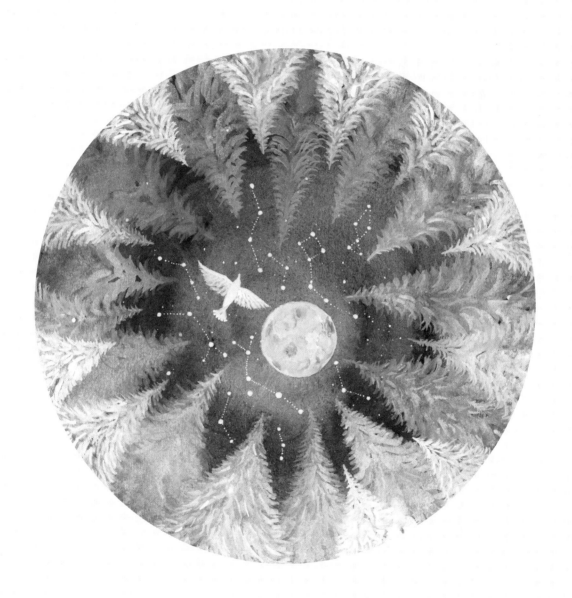

Have you ever gazed at the night sky in wonder and awe, and felt a need to somehow capture or contain its vast splendor into something more intimate and understandable? It is not uncommon for us humans to feel overwhelmed by the enormity of the universe and our tiny place in it. Millennia of artists, philosophers, and storytellers have drawn inspiration from the stars, and over time we have tried to grasp the vastness of the heavens by identifying and naming familiar clusters of light that we could repeatedly locate and refer to.

Nearly everyone has heard of the Big and Little Dippers in the Northern Hemisphere. Some cultures refer to them as Ursa Major (The Great Bear) and Ursa Minor (The Little Bear). Other familiar constellations were noted by the ancient Greeks, and bear Greek names: Orion, Cassiopeia, and the Pleiades, for example. Arguably, however, it is the zodiac constellations that have had the greatest impact on humanity.

The study of the physical universe—its stars, planets, and space—is called *astronomy*. The study of the movements of heavenly bodies as they affect the world and human affairs is called *astrology*. Astronomy is science; astrology is more of an art or philosophy. The field of knowledge in both practices is as enormous as the cosmos itself. An astronomist may spend her life studying a tiny fraction of the galaxy, while an astrologist can spend a lifetime pursuing the subtleties of polarity, mutability, modality, and dignity in his art.

This book is not about either discipline. It is an art book about painting constellations, and as such the entire scope and depth of the philosophy and practice of astrology in particular is beyond our ability to explore here.

It is our intent in this book to help you capture the wonder of the night sky by learning to paint the constellations of the zodiac. Each constellation will be demonstrated by Elise, and she will provide tips and techniques for placing these constellations on your canvas, as well as where to locate them in the sky. Background information on the signs and their characteristics in astrology will also be provided. We will end with a discussion of the moon and its phases in different cultures as well.

—D.R. McElroy

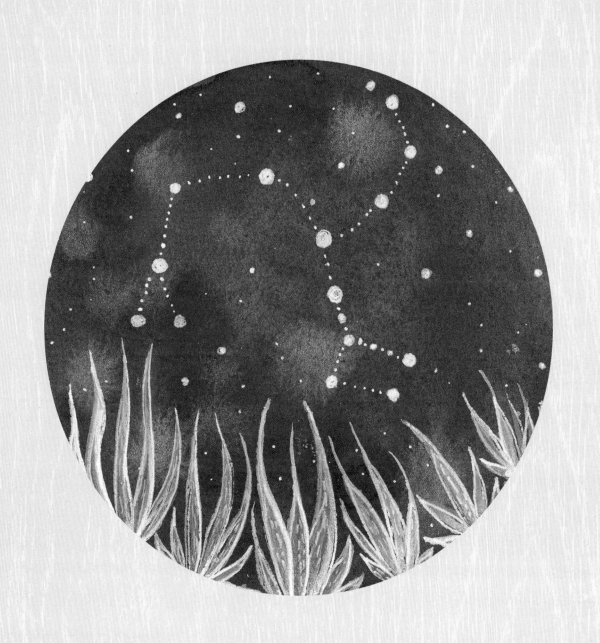

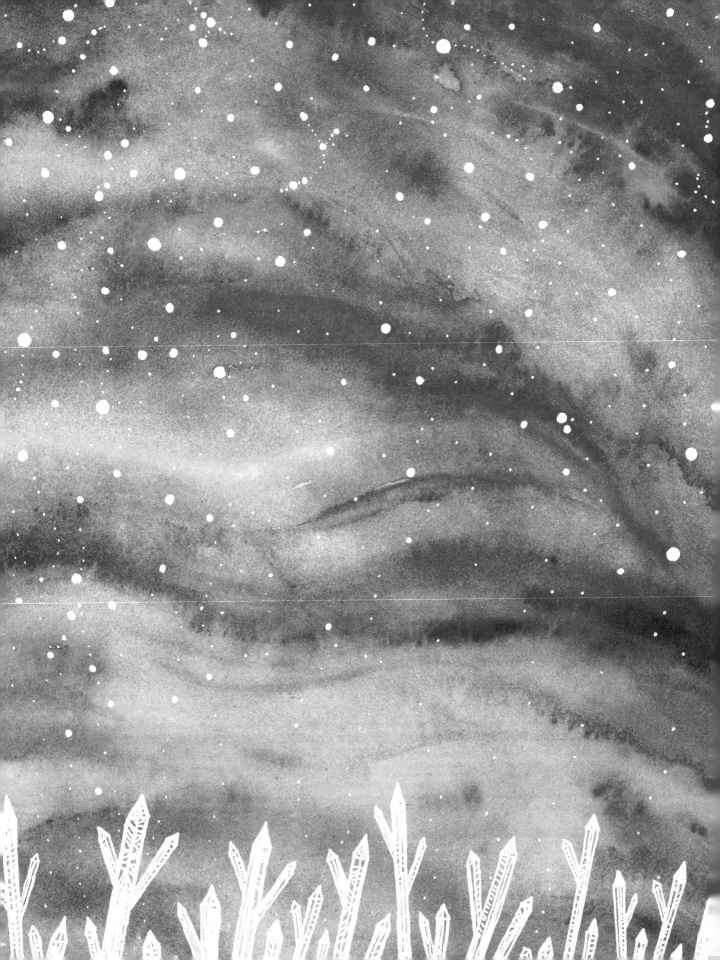

1

Tools & Techniques

Watercolor is an incredibly diverse medium, and with just a few materials you can create your own celestial paintings inspired by the beauty and power of the cosmos. In the following pages I have included a few of my favorite tools and materials that I work with. However, I encourage you to experiment with a variety of paints, pens, brushes, and papers throughout your artistic journey, as you will certainly find something unique that works for your style of watercolor painting. It is my hope that this book will inspire you to explore the endless possibilities that watercolor has to offer.

TOOLS
Watercolor Papers

There are several different types of watercolor papers you can use to make your paintings. There is hot press (smooth); cold press, which has a little texture to it; and rough press, which has the most "tooth," or texture, to it as well as the longest dry time. I generally prefer to paint on cold-press watercolor paper for most of my paintings, as it contains a beautiful rough texture in addition to being smooth enough to achieve incredible detail with both watercolor and ink.

As with any material, I think it's a great idea to try out a range and decide what works best for your paintings. You will find that hot press has a smooth quality to the paper, and as a result, the paint will dry faster. I like the rougher textures because it also gives me the ability to work in layers without worrying about saturating my paper with too much paint, or causing the paper to shed, buckle, or rip. I tend to work on heavier, artist-grade papers so that I can layer and experiment.

There are some great student-grade papers made by Strathmore that are 140 lb, which tells you the weight or thickness of the watercolor paper. You can purchase as thin as 45 lb and as thick as 300 lb. For most of my celestial paintings, I like to use extra-heavy 300 lb paper, because making a luminous sky requires much layering. Below I have included a list of a few paper suggestions that might assist you in choosing an appropriate watercolor paper. Artist-grade paper is generally a better price and is good for studies and smaller works. I like professional watercolor paper because it is archival, which means that it will not age or yellow over time.

Once I have chosen my paper and cut it down to the appropriate size, I tape off the edges with masking tape onto a drawing board to achieve a crisp line for my full-page landscapes and to keep the surface of my paper from buckling while I work. This also gives me a good amount of space to frame my painting once it's finished. For my circular paintings, I generally use a compass, or sometimes a circular embroidery hoop, as a template.

PAPER AND SKETCHBOOK SUGGESTIONS

Strathmore paper • Reeves BFK paper • Fluid 100 watercolor paper
• Arches watercolor paper • Moleskine journal (it makes an excellent watercolor sketchbook for rough sketches)

Watercolor Paints

I have several favorite watercolor brands that I use and adore for different reasons. I like Sennelier, due to its soft, buttery, and easy-to-mix qualities. I also love Winsor & Newton, as they have a great range of watercolor products, from student to professional quality, and I also have a weakness for Gansai Tambi Pan watercolors, due to their delightfully overwhelming array of colors within their 36-pan set. I will gladly find any excuse to purchase and test new watercolor paints, since all have such unique qualities, but the above three are my favorites, because they are bright, vivid, and lightfast, and can be used in combination with other water-based media, such as walnut ink, metallic pigments, and gouache. Below is a more comprehensive list of paints that will also work well for making celestial paintings.

WATERCOLOR SUGGESTIONS

Winsor & Newton Cotman watercolors • Sennelier watercolors
• Gansai Tambi Pan watercolor set • Holbein watercolors
• Dr. Ph. Martin's watercolor inks

Paintbrushes

I have tried and, sadly, destroyed a great many paintbrushes during my time as a painter. I used to purchase top-quality brushes when I worked at an art store and was able to justify the expense due to my employee discount. However, over the years I have realized that I am particularly brutal on my brushes, and despite my best intentions, I ruin all of them quickly no matter what quality they happen to be. As a result, I tend to mostly purchase inexpensive, round, nylon brushes.

There is a wide range of brushes that are great for landscapes. I buy round, flat, and angle brushes for different purposes. I use an angle brush because it is good for circular paintings and has a great edge. I like size 4. For my watercolor washes I use a ½-inch (1.3-cm) flat brush to lay down the color. I also use a larger ½-inch (1.3-cm) flat wash brush to create my larger skies. I use 000 and 0000 brushes, which are just about as small as you can get. These brushes are great for details like stars, constellations, and botanical details like leaves, bird feathers, and grasses. A small round detail brush such as a 4 is nice to have for larger areas and for texture on rocks and mountains. I especially like Winsor & Newton Cotman synthetic watercolor brushes, because they are reasonably priced and hold their points despite my harsh treatment.

There are some amazing natural watercolor brushes on the market as well. They are generally made of squirrel or sable hair, and you will find that they hold their point longer and will hold more water. Prepare yourself to put forth a much larger investment for them than you will for synthetic watercolor brushes.

Finally, I like to use water brushes, which have a small reservoir for water attached to them, so they are excellent to do a variety of watercolor washes with, and you can control the amount of water that comes out of the brush. Water brushes are especially fun to use to create night skies, because they spread water so well. They are also great for wet-on-wet technique, which is an effect that I used for all the skies in my zodiac paintings (see page 31). Below are some of my brush suggestions:

BRUSH SUGGESTIONS

Winsor & Netwon Cotman synthetic brushes • Princeton brushes • Niji water brushes • Sakura Koi water brushes

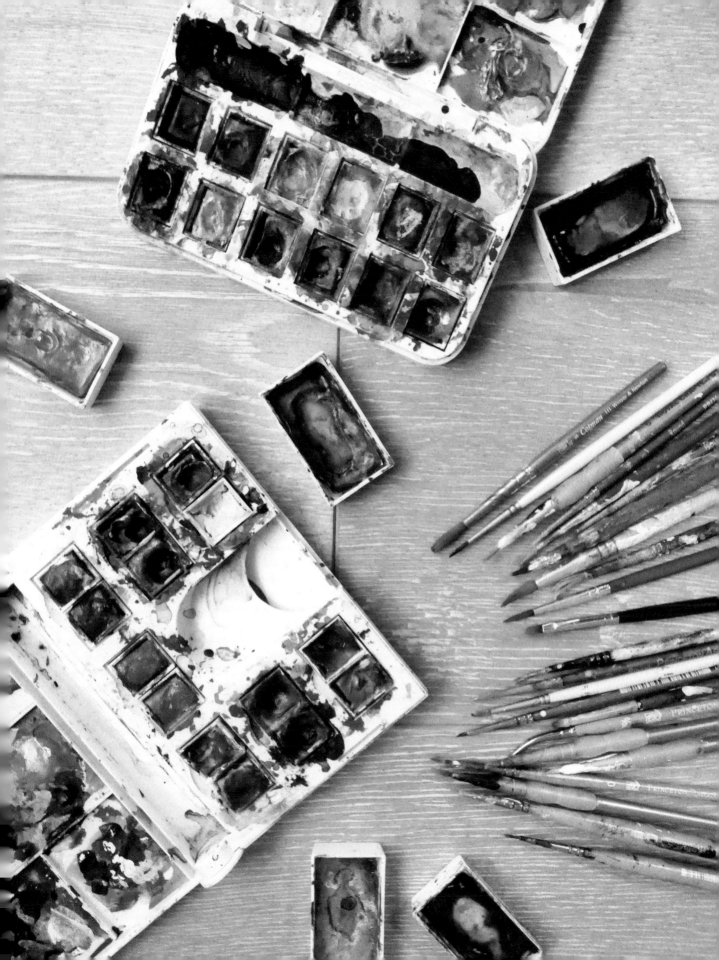

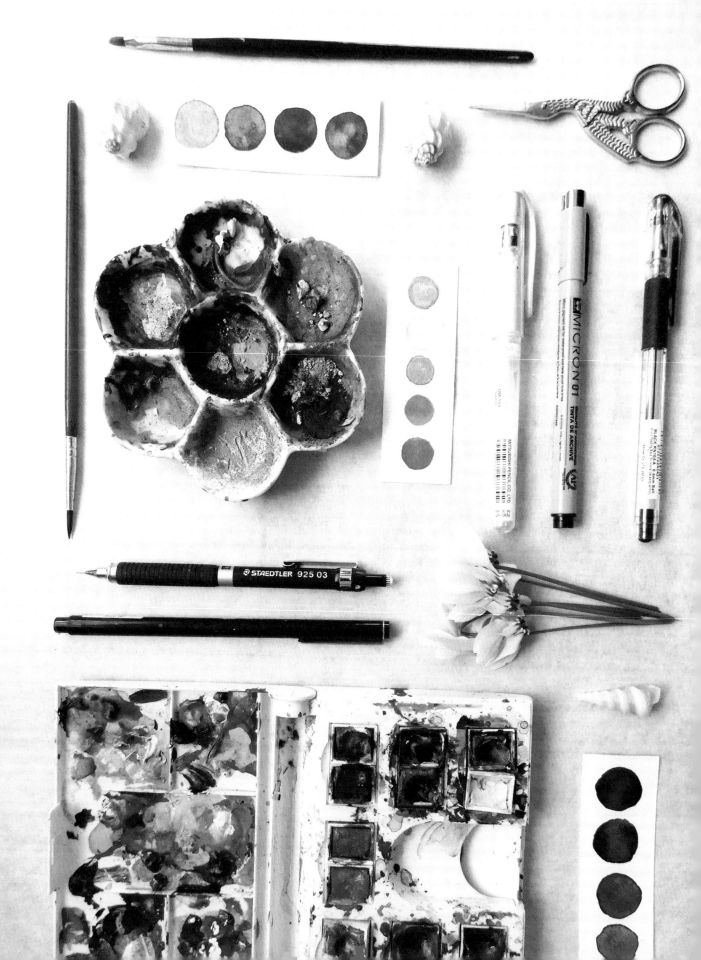

Pens & Pencils

I adore all art materials, which can be seen in my pen and pencil collection as much as in my paint collection. For most of my celestial paintings I use Sakura Pigma Micron pens, mechanical pencils, and Uni-ball white gel pens during my creative process. Because I also regularly use them in my sketchbook drawings, I like to have a lot of variety. I also like using water-based inks, such as walnut ink, so I occasionally use a Speedball calligraphy pen for some of my detail work.

PEN AND PENCIL SUGGESTIONS

Sakura Pigma Micron pens • Sakura White Gelly Roll pens
• Uni-ball white gel pens • Staedtler pencils

Work Area

always start any new project with a clean desk and easel. To stay motivated, I clean my studio before I start any new work, and although it tends to get messy when I'm in the middle of a new painting, it is part of my process. I also share my art studio with my husband, Matthew, who is a sculptor, and with our two-year-old son, Miles, who absolutely adores painting and wants to be involved in every project. We are all constantly inspired by each other, and even though I never get as much work done as I might like, working in the studio as a family gives us the opportunity to create together and to raise our son in an artistic environment, so I wouldn't have it any other way.

TECHNIQUES

I like to work from my natural surroundings as much as possible, so I take a lot of reference photos when I am in nature to serve as inspiration when I need a new idea for a painting. I also keep a list of ideas for new paintings that I regularly add to my sketchbook so that I have a bunch of ideas ready to use. I also collect leaves and botanical elements, which I press into my sketchbooks and display in my studio. These everyday mementos provide me with color inspiration when choosing a color palette for a new piece, and they also serve as a source of inspiration for life drawings.

When I decide on an idea for a painting, I first try several variations in a set of sketches to be sure I have a successful composition before moving on to my good watercolor paper. I try to always keep in mind that composition is really up to the taste of the viewer. I have made paintings that I personally did not feel were quite the right style or composition I originally intended, yet they sold to a buyer who felt very differently. Therefore, I think it is up to *you*, as the artist, to decide what works in your painting. For example, if your botanical details feel too crowded, there is a good chance they probably are; however, the overcrowded quality might really work for a viewer, so I suggest showing your sketches and paintings to a friend or partner for a second opinion before scrapping an idea or a composition. Sometimes it just takes another person to see something in your painting that speaks to her or him to know you have created a good composition.

Themes

I have been collecting art history and natural history books for as long as I can remember. My book collection has long been a place to which I can turn for researching and learning about artists and painting techniques. I aim to discover the different ways that art has influenced humanity, and what themes and symbols emerged at different times throughout history. As you can imagine, the night sky is a constant source of inspiration for so many great artists, and it is amazing to see such a diverse array of artistic depictions of the cosmos. My book collection has been a part of my life for so long and reminds me of how far I have come as an artist, and it keeps me constantly wanting to learn and evolve as an artist as well.

I also use a sketchbook in my painting process because it helps me with the preliminary layout, composition, and colors for a painting. In addition, I usually experiment with mixing colors and painting swatches, which allows me to be sure my color palette works well before I move on to my final painting. For my night sky paintings, I like to alternate between creating imaginary constellations and studying astronomy books to learn about the ones that actually exist in the sky.

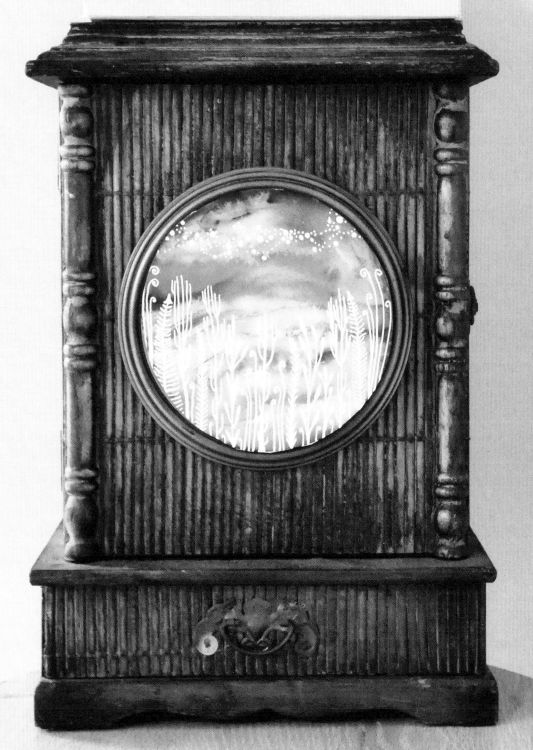

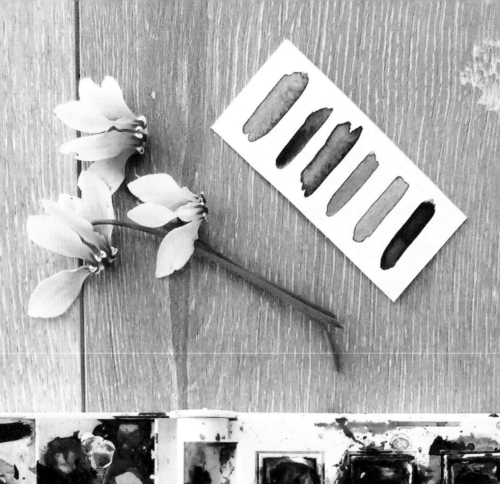
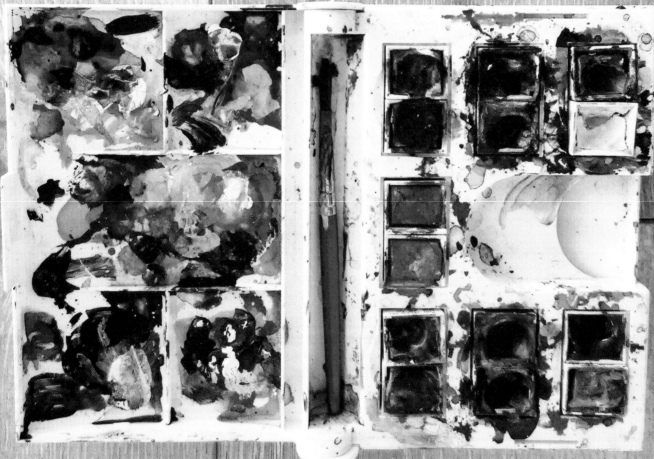

Painting with Watercolors

Painting with watercolor is really about experimenting with what incredible things paint can do when you apply it to your paper in different ways. Over the next pages, you will find descriptions of various effects that will work beautifully for creating your celestial paintings. There are a great number of other techniques for watercolor, and I suggest you explore them if you find yourself loving these effects, as they are really just a starting place when first exploring watercolor painting. These effects are the ones I use the most to create my skies, and I experiment in my sketchbook so that I can be sure I like an effect for my painting.

I like to mix paint samples and swatches when I am working on a new piece, and if I am working on a long-term or large project, I mix several colors ahead of time. This way, I do not have to think about how I mixed the colors later in my painting process. Also, it can help to have a few palettes, including one with small-lidded paint containers, readily available to mix and label your washes. When I was starting out as a painter, I struggled to remember how or what I used to mix a color, so it can really help to make notes or swatches when mixing colors so that you know exactly how you made that gloriously verdant green shade, for example, and be able to create it as many times as needed.

Once you have a good sense of the colors for your painting, it is time to decide how you want to lay that color down and which technique will work best for your purposes. I tend to start with an underpainting, which can help you decide whether you want your painting to be focused on a range of warm or cool colors. The underpainting can really determine that in a sky. For example, for most of my zodiac paintings, I started with a very light wash of the color I want to work with, and I lay that wash down first with a small amount of water. I let that wash layer dry, and then I choose a slightly darker version of that color for my second layer. I go back into my painting with a medium round brush (4) and add a small amount of water to make the pigment flow back over my first layer. These two layers blend together, and give you a luminous and flowing sky.

In addition to washes, there are two main watercolor painting techniques: wet-on-wet and wet-on-dry. Each has its advantages. I like both techniques and use them often. I find that when I'm working on my skies, a wet-on-wet technique blends the best because it spreads the paint across the paper in a soft and unpredictable way. I tend to use wet-on-dry techniques for creating a more opaque quality in my skies, because the paint will flow and move across the paper less when there is less water involved, so it makes for a good minimal background.

Washes

There are several types of washes that can help you create a beautiful sky. The first is a graded wash, which is a technique that starts with a dark color. When you add water, your wash gradually lightens near the bottom of your painting, creating a lovely ombré effect that makes for a luminous and magical sky. The second is a flat wash, which creates an even distribution of a single color on your page. Once this layer is dry, you can go back in a second time with other complementary colors to make your sky pop, or you can leave it for a very minimalist and stark-looking sky, which works well for a winter scene. Finally, a two-color wash or gradient wash uses two colors on a wet surface. You can either use two different colors or the same color in varying degrees of pigment intensity; they will mix and blend together when dry to produce a lovely effect.

Wet-on-Wet Technique

The wet-on-wet technique begins by adding a water wash onto the paper *before* adding your preferred paint color. This first wash will cause the watercolor paint to spread and bleed across the paper in a beautiful and unpredictable way. I use a ½-inch (1.3-cm) flat wash brush to lay down a thin coat of water, but you could also add a small amount of color for a light wash. For my skies, I like to add a very small amount of gold metallic pigment to my water for this step, so that the gold paint will re-wet when I lay down my second layer of paint and create that lovely metallic effect. After I lay my wash down, I then go in and apply dark to light pigments with whatever colors I have chosen for my sky.

Wet-on-Dry Technique

The wet-on-dry technique begins by loading a flat 1-inch (2.5-cm) wash brush with a color and painting directly onto the paper. This technique allows for a more controlled distribution of paint, but gives less of a transparent, flowing quality than the wet-on-wet technique provides. Both are great techniques, and for my skies I tend to use aspects of both within the same painting. For example, I will lay down a light water wash onto a small part of my painting, then load my brush with pigment and work on the dry part of the paper near where I laid down my wash. I let that paint slowly blend with the wet areas, creating a bolder, more pigmented area alongside a softer, blended area. There is less of a spreading effect with wet-on-dry technique, but it provides an intense, dark quality to certain areas of your sky.

Colors & Effects

My favorite colors to work with are rich, saturated tones, such as blue, green, and hints of red, gold, and metallics. I always try to expand my palette by experimenting with different color combinations in my sketchbook, and I make lots of test colors and swatches before I settle on a color scheme for a new painting. As important as I believe color theory is to the art-making process, I also believe that you, the artist, will intuitively know which colors work best for your painting. There is no harm in trying out a color only to realize that you want to paint over it and use the initial color as an underpainting. I recommend letting a color dry completely first, so as not to muddy your painting, but generally that extra layer will just give your painting more depth.

In the next chapter are some of the colors I like to use for representing the seasons. I like to use a light wash to start off these paintings. There are several lovely watercolor effects that you add to a wash using household items such as salt or rubbing alcohol. It can be fun to create a unique sky by laying down a light wash and then using a sprinkle of salt over it and letting it dry. Once dry, the salt rolls off and you will see that the places where the salt is laid down resist pigment. When you lay down a wash of paint and then drop a small dot of rubbing alcohol from a small round brush (I generally use a 000 round brush), you will see that the alcohol repels watercolor and spreads in a really unique and unpredictable way. You can find examples of these two effects in several of my seasonal paintings starting on page 105.

Other color effects that can create a unique sky are splattering techniques, where you load any small watercolor brush with a small amount of paint and water, then tap it against another brush or item directly above your painting (be sure to tape off or cover areas of your painting that you don't want splatter on, as this process is messy and chaotic). The splatter process doesn't allow for a whole lot of control, but it will create a beautiful and unique effect in your sky. See the summer painting on page 109 for examples of this splatter technique.

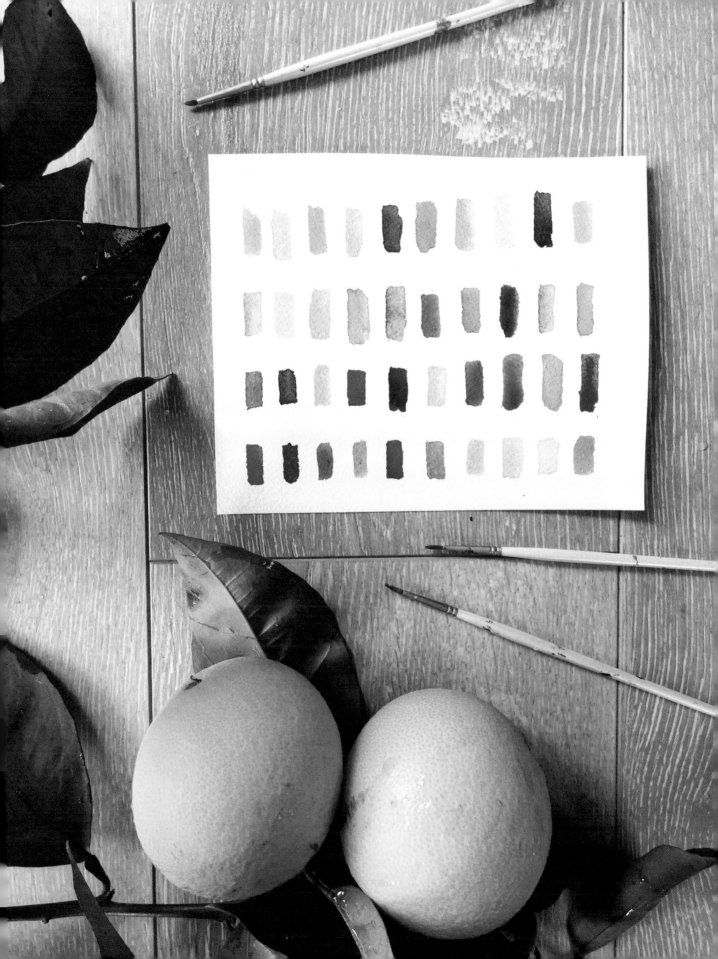

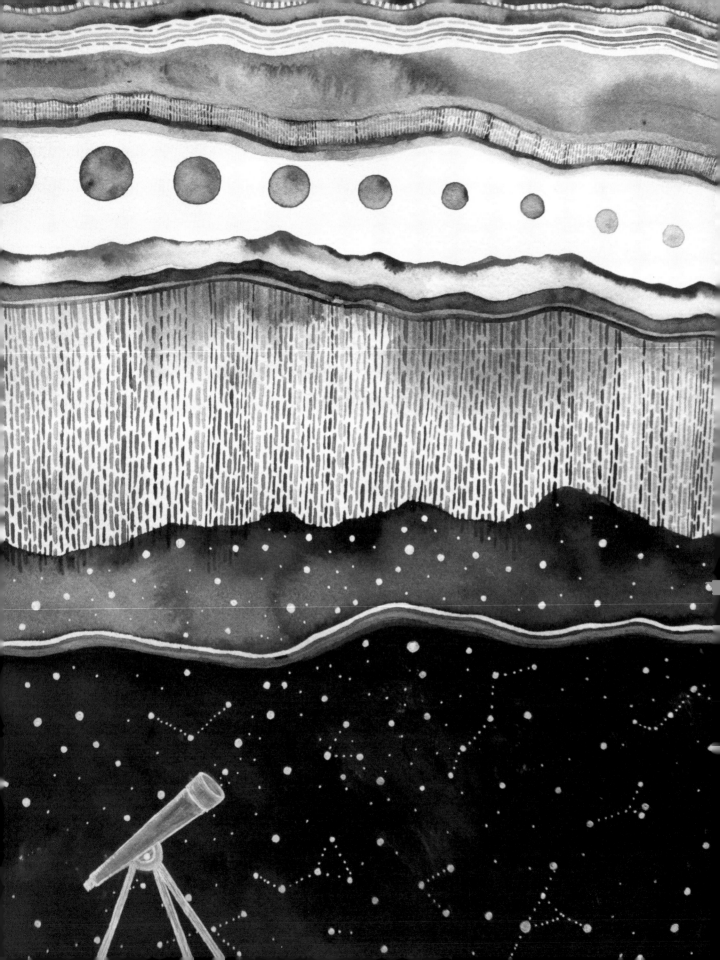

2

Astrological Signs

Astrology is an art practiced in ancient times. It divided the night sky into twelve sectors, each identified by a constellation within it. Over the millennia, the constellations have migrated somewhat, and don't always match the quadrant assigned to them. The term zodiac is from the Latin *zōdiacus,* meaning "circle of animals."

The roots of the zodiac are in Babylonian and Egyptian astrology, which later influenced the Greco-Roman practices. Astrology maintains that the movements of celestial bodies influence the personality, behaviors, and even fate of humanity. It purports the notion of "as above, so below." Different astrological systems measure space and celestial movements in different ways. In this book, we will be referring to the Western-modern practice (as opposed to the Western-classical practice). The modern take on astrology changed with the discovery of several new planets in the late nineteenth and early twentieth centuries.

Modern Shamanism—a practice that rose in the 1980s with a wave of new awareness and a desire to connect with ethnic cultural practices—has also developed its own system of astrology. The signs are referred to as "totems" and utilize native wildlife instead of constellations and mythology, but the dates still correspond to those of traditional Western astrology. Each sign's corresponding totem will be included in the discussion, just for fun.

A note on Chinese astrology: while this practice has a zodiac with twelve symbols, the emphasis of this system is not movements through space, as in Western practices, but rather movements through time. Chinese zodiac symbols rotate through a twelve-year cycle, and each new year begins following the celebration of Chinese (or Lunar) New Year. That day changes from year to year, so the whole system is in constant flux and doesn't match up with the Western zodiac. For the sake of our theme (the constellations), we will leave out further discussion of the Chinese zodiac.

Strictly speaking, classical astrology is concerned with the placement of the sun in the sky at the moment of a person's birth. Creating a zodiac chart takes into account positions of the moon and planets as well, but your sign is determined by the sun. Because the sun doesn't change position relative to the Earth (unlike the moon's orbit), the dates of the zodiac signs remain fixed. Different sources may vary the dates by a day or two.

Each sign has a planet that "rules" it, as well as a symbol, an icon or avatar, and personality traits that are said to be characteristic of people born under that sign. Additionally, the signs are associated with one of the four traditional Earth elements: fire, earth, air, and water. The signs are discussed by elemental group over the following pages. Opposite is a list of the sun sign dates beginning with the first sign of the celestial year, which occurs at the spring equinox.

ARIES
March 21–April 19

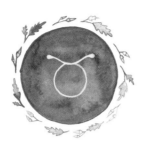

TAURUS
April 20–May 20

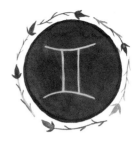

GEMINI
May 21–June 20

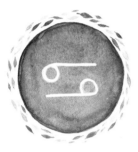

CANCER
June 21–July 22

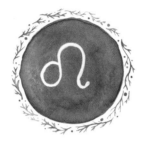

LEO
July 23–August 22

VIRGO
August 23–September 22

LIBRA
September 23–October 22

SCORPIO
October 23–November 21

SAGITTARIUS
November 22–December 21

CAPRICORN
December 22–January 19

AQUARIUS
January 20–February 18

PISCES
February 19–March 20

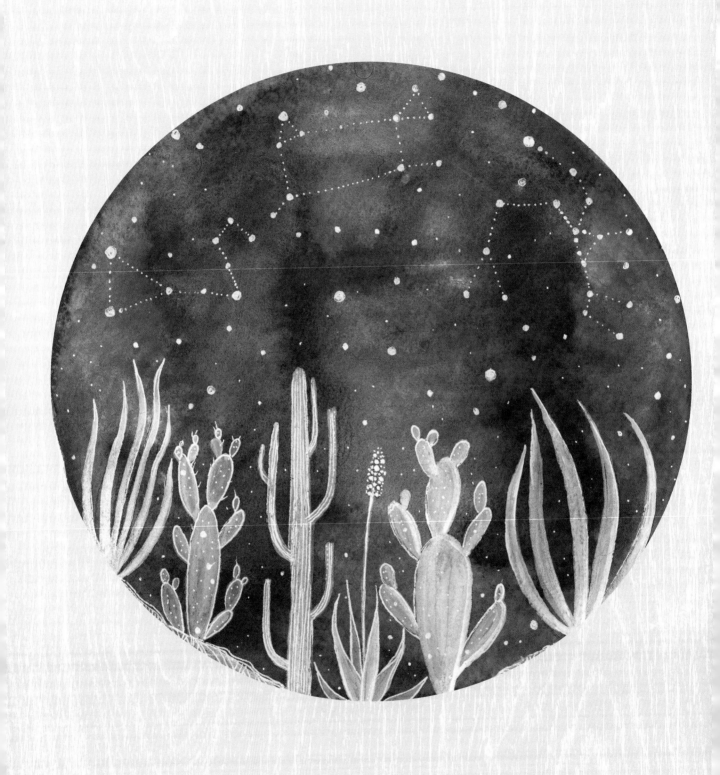

FIRE SIGNS

ARIES LEO SAGITTARIUS

masculine

self-expressive

choleric (Hippocratic temperament)

faithful

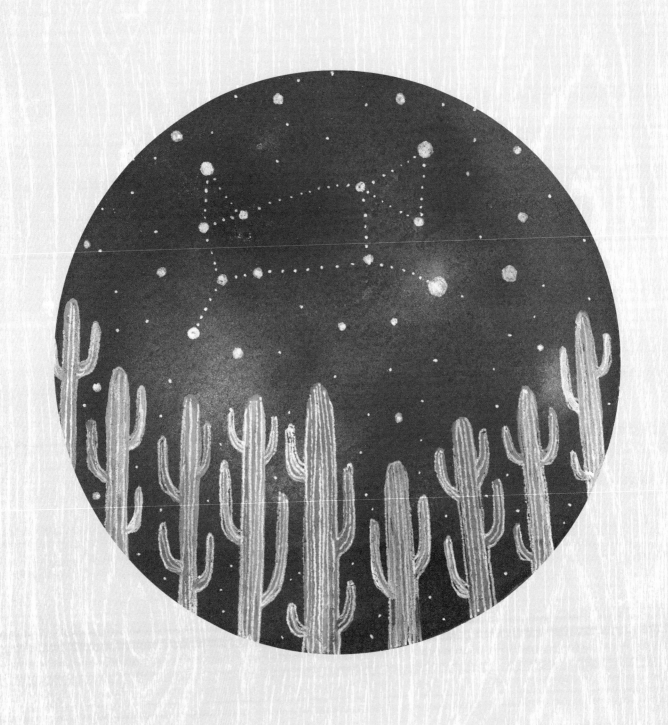

ARIES: THE RAM

MARCH 21–APRIL 19

As the first sign of the zodiac, Aries represents birth. Like infants, Rams are typically completely self-absorbed. They are mainly concerned with their own needs and wants. They are rule breakers and are not concerned with what other people think of them. It is their charm and complete lack of guile that keep their narcissism from annoying others. Rams can't lie well; they are open books. Ram people are noted for being exuberant, brave, and energetic; they are not passive people. Aries make for good friends, as they always look out for those close to them. Cheerful, curious, competitive, and honest, Rams often make great leaders. Their passion and drive lead them and their teams to great success in business, sports, and the military. Their passion is contagious, and they need to be allowed to forge their own paths; cubicles crush their spirit. Rams do not like to take orders from anyone, and if given one, they can become moody and can sometimes take offense. They pride themselves on their independence.

The symbol for Aries represents the face and horns of a ram. The ruling planet of Aries is Mars, Roman god of war. This is one reason the military suits Aries people well. Darker aspects of the Aries personality include impulsiveness, impatience, willfulness, and aggression. Underneath their strong and independent shell, they can sometimes be insecure and place too much pressure on themselves. Famous Rams include Robert Downey Jr., Emma Watson, Charlie Chaplin, Joan Crawford, Bette Davis, Houdini, Vincent van Gogh, and Thomas Jefferson. The Modern Shamanist totem for this corresponding month is the Falcon.

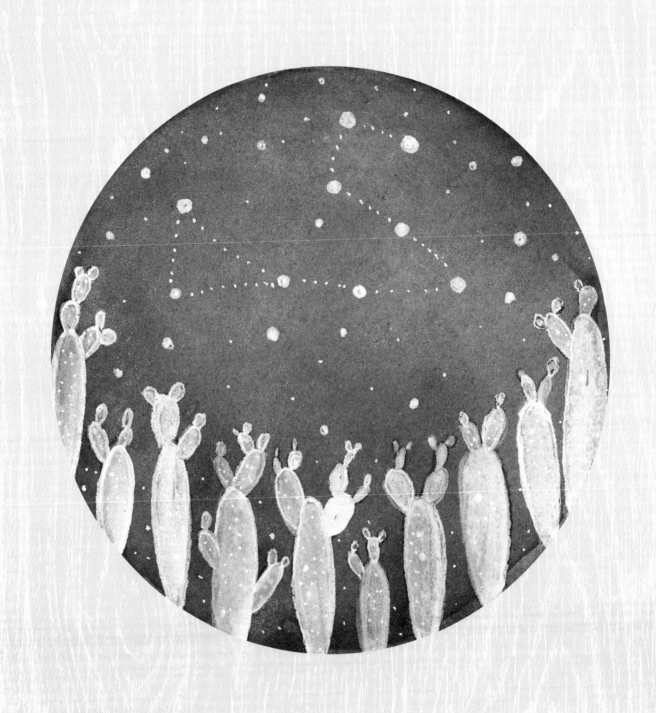

LEO: THE LION

JULY 23–AUGUST 22

A group of lions is called a "pride," and Leos are particularly noted for their pride. Whatever project a Leo has going, they will be going about it in a meticulous and thoughtful way, with attention to detail and craftsmanship. The Latin word for "lion" is *leo*. In addition to pride, Leos are known to be generous, loyal, and thoughtful. Leos are happy people, and have a great ability to bounce back when they are down. Their natural enthusiasm attract those around them, and people tend to gravitate towards them. They also do not hold grudges and are very forgiving. They thrive in the spotlight and are drawn to high-profile positions that can make them superstars. Entertainment, corporate management, entrepreneurship, and pro sports suit them well.

Leos are typically quite feline: they love the good life, good food, and sunshine. They move with sliding grace and sit indolently. There's no such thing as an introverted Leo—though some may pretend to be to avoid excessive demands on their time. Leo is the fifth sign of the zodiac, representing vitality and strength. The ruling body of Leo is the Sun, again upholding this sign's reputation for star quality. Unsurprisingly, Leos can be arrogant, temperamental egomaniacs; they may need constant pampering and accolades to buoy fragile egos. But most Lions are idealistic forward thinkers. And you will not find a more loyal partner. Famous Leos include Jennifer Lopez, Kylie Jenner, Percy Bysshe Shelley, Carl Jung, Lucille Ball, Fidel Castro, Jacqueline Kennedy Onassis, Alfred Hitchcock, Julia Child, and Barack Obama. The Modern Shamanist totem for this sign is the Salmon.

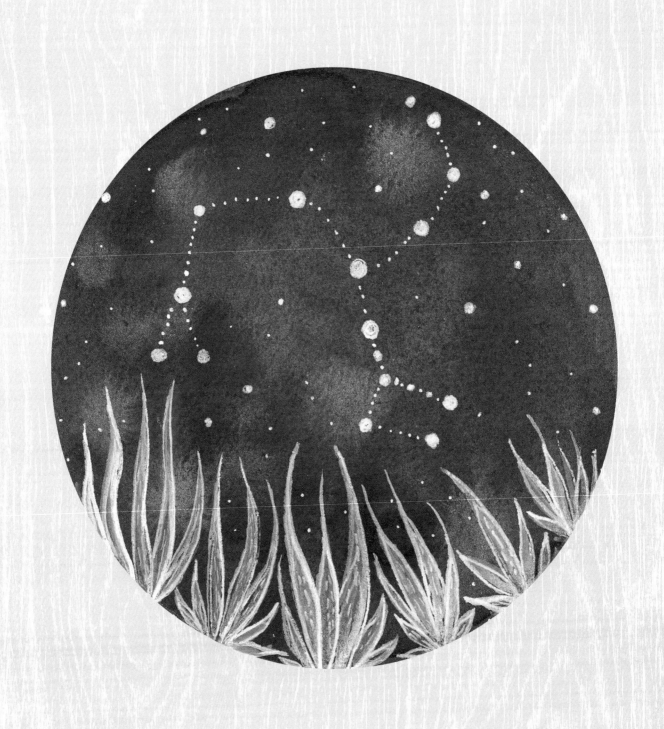

SAGITTARIUS: THE ARCHER

NOVEMBER 22–DECEMBER 21

The Archer in Sagittarius is often represented as a centaur, the mythical half-man, half-horse of Greek/Roman legend. Sagittarians are larger-than-life personalities with big hearts and a great sense of humor. They'll always be the life of the party. They commonly make inappropriate remarks, and then fail to understand why people are mad at them. They mean no harm and are completely without guile. Their bluntness is usually delivered with a laugh and breezy ease. When they discover that they've really hurt someone's feelings, they will be dismayed and crushed. What they lack in tact they make up for in wit and good nature.

At work, they demand stimulation, change, and high-energy situations. They hate being boxed in, and are known to rebel against authority. "Knowledge is Power" is a Sagittarius motto, and Archers never tire of learning new things. This sign is known for curiosity, charm, compassion, and boldness. Optimism and independence are also strong here. Archers make wonderful lawyers, teachers, journalists, and pilots. Though famous for their joviality—Jupiter being the ruling planet—Sagittarians often have hair-trigger tempers.

The symbol for Sagittarius is an arrow in flight. The ruling planet Jupiter is the largest planet in the solar system, and demonstrates Archers' joviality, big heart, and boisterousness. Jupiter also makes them prone to excess. The restlessness in this sign may cause them to be superficial, indifferent, or brash. Sagittarius is the ninth sign of the zodiac, representing satiety, generosity, and independence. Famous Sagittarians include Bruce Lee, Jimi Hendrix, Jim Morrison, Ozzy Osbourne, Emily Dickinson, Walt Disney, Mark Twain, Beethoven, Brad Pitt, Scarlett Johansson, Britney Spears, and Winston Churchill. The Modern Shamanist totem for this sign is the Owl.

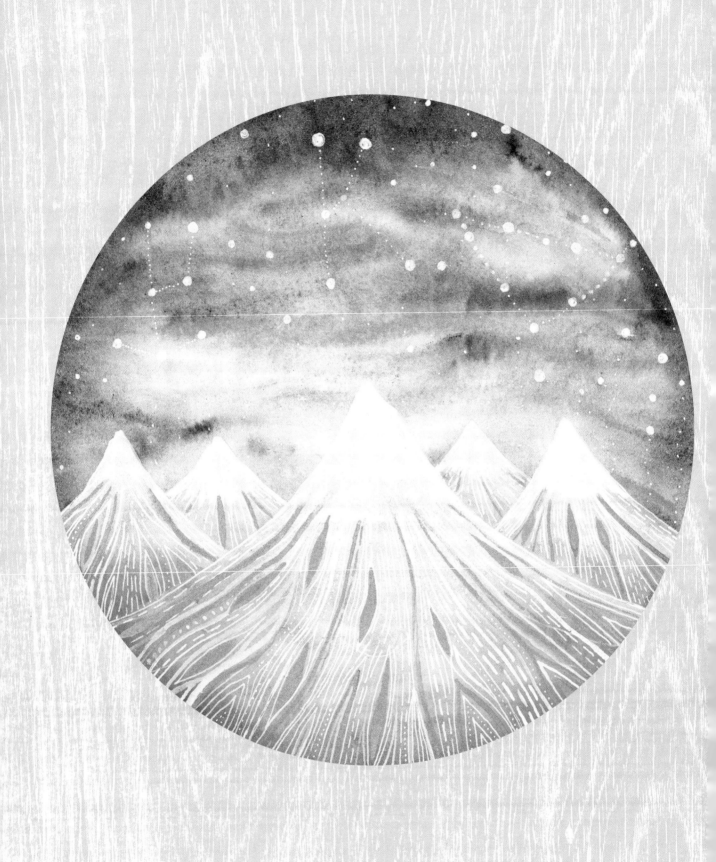

EARTH SIGNS

TAURUS VIRGO CAPRICORN

feminine

self-containing

melancholic (Hippocratic temperament)

practical

cautious

materialistic

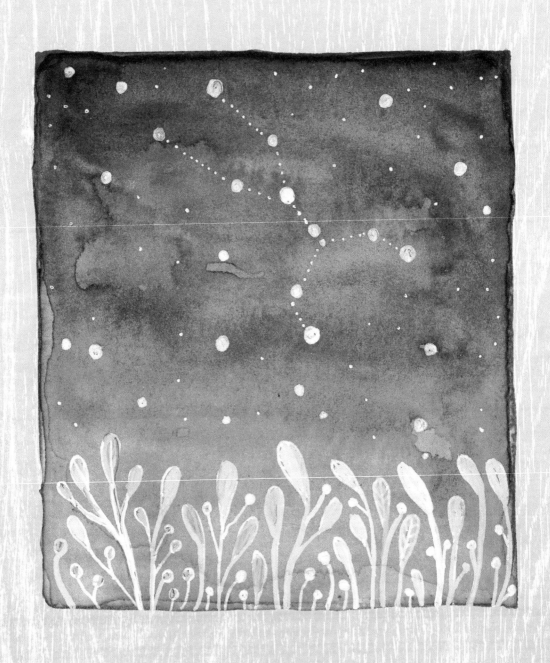

TAURUS: THE BULL

APRIL 20–MAY 20

People born under the sign of the Bull are credited with being romantic, patient, hardworking, and persevering. The bull is a symbol of great strength, and Taurians are nose-to-the-grindstone people; they are organizers, planners, and strategists. Once the planning is done, it's full steam ahead. Taurians enjoy routine and stability. They make terrific project managers and bankers. They also excel in creative jobs like photography and fashion design. Taurians are typically creatures of few words and display a soulful thoughtfulness and calm demeanor.

Bulls are generally placid, but never dumb. They prefer to move slowly and deliberately, planning every step. Taurians are empire builders; they accumulate wealth and power slowly and steadily. Power gives them security, but they are not ones to wield it. They would rather sit back and smell the daisies while someone else does all the hard work of managing their affairs.

Bulls take whatever life throws at them and throw it back. Though generally even-tempered, Taurians can be explosive when pushed too far. Taurus is the second zodiac sign, representing the fertility and possibility of spring, as well as hearth and home. The symbol for Taurus represents the face and horns of a bull. They have a commanding presence that intimidates, despite their generally easygoing natures.

The ruling planet of Taurus is Venus, goddess of love and beauty. Taurians value art and aesthetics, and often have impeccably decorated homes and offices. They frequently are collectors of fine art, especially paintings. Famous Taurians include Mark Zuckerberg, Shirley Temple, Ulysses S. Grant, Sigmund Freud, David Beckham, Adele, George Clooney, Tina Fey, Jack Nicholson, John Cena, Channing Tatum, Ella Fitzgerald, Jerry Seinfeld, Queen Elizabeth II, and William Shakespeare. The Modern Shamanist totem for this sign is the Beaver.

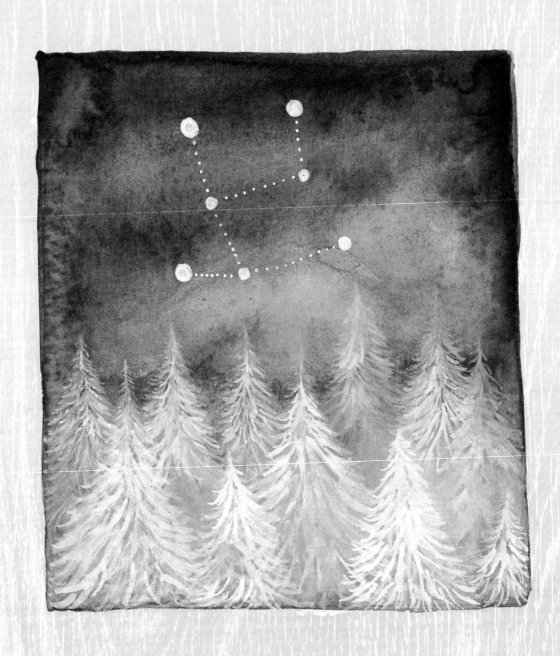

VIRGO: THE VIRGIN / MAIDEN

AUGUST 23–SEPTEMBER 22

Perfectionistic, practical, elegant, modest—just what you'd expect from the sign of the Virgin. Virgos like order and thrive in detail-oriented careers like accounting, health care, and lab research. But this sign is just as meticulous in fields such as filmmaking, business start-ups, and editing. Virgo is generally not the sign to seize the leadership spotlight, but because of their purposeful natures and the admiration of their peers they may frequently inhabit those positions.

Virgos frequently seem to have weighty problems on their minds; the sign is given to excessive worry and concern. These people are often workaholics, staying late at the office to take care of some detail or other. Virgos are typically even-tempered, calm, soothing individuals when they aren't overworked. A Virgo is often very concerned with how they look, taking great care in their dress and grooming. Virgo people will be the first to roll up their sleeves and pitch in to help finish a task—not for glory or personal gain, but simply to put an end to procrastination and finish the job. They despise loose ends.

People born under the sign of the Virgin are typically frugal—with both their love and their money. Virgos are not particularly demonstrative folk, and they are notoriously stingy. Virgo is the sixth sign of the zodiac, representing responsibility, maturity, and thrift. The symbol for Virgo is an amalgam of the first three letters of the Greek word *parthenos*, meaning "virgin."

Mercury rules Virgo, so don't be surprised if practical, fastidious Virgos do a sudden about-face seemingly out of nowhere. Their highly attuned perceptiveness may have them taking note of something the rest of us can't see. Famous Virgos include Warren Buffett, Tim Burton, Michael Jackson, Mother Teresa, Henry Ford II, Greta Garbo, Sean Connery, Arnold Palmer, Sophia Loren, Kobe Bryant, Gene Kelly, Gene Simmons, Lyndon B. Johnson, Queen Elizabeth I, and William H. Taft. The Modern Shamanist totem for this sign is the Brown Bear.

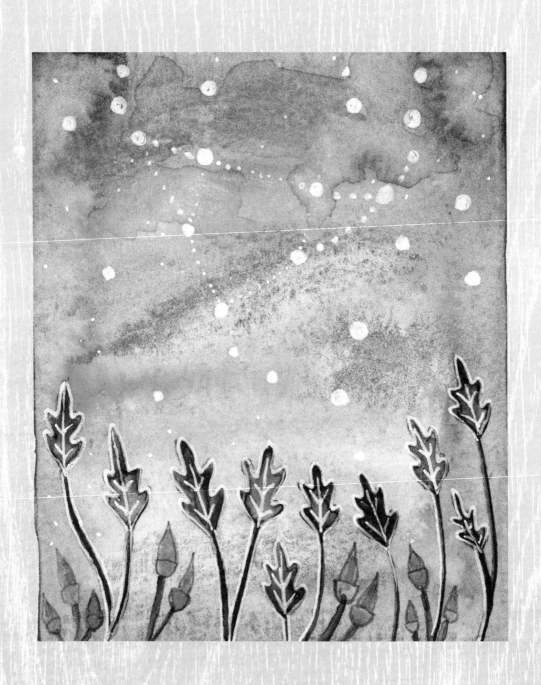

CAPRICORN: THE (SEA) GOAT

DECEMBER 22–JANUARY 19

Earth signs all share the traits of practicality and persistence, and Capricorn is no exception. They win by playing the long game; Sea Goats are strategists that use an opponent's strengths against him. Goats don't climb fast, but they climb sheer cliffs that are impossible for others to scale. This sign is also intelligent, reliable, and endearing. They have a strong work ethic and enormous willpower, allowing them to excel in power positions. Business, law, and finance are well suited to this sign.

Capricorns are strategists; they aren't the flashy stars with big egos. This sign blends into the background and often goes unnoticed—until the winnings are tallied. Status and financial success are important to them. Sea Goats are not really "people" people; they are generally solitary, opinionated, and often suspicious. Satisfaction for them comes from a job well done. Coworkers and employees will recall a Capricorn's deeds and legacy, not their warmth or demeanor.

The Sea Goat relentlessly plods along the path to success. Saturn's influence often gives Capricorns a melancholy air. Sea Goats respect the successes of those who came before them and cherish the established order of things. Serious-minded, self-controlled, and tenacious, this sign may also be obstinate, pushy, and grouchy.

The symbol for Capricorn is the stylized horns and body of a goat with the tail of a fish. This shows Capricorns' ability to blend in with different environments, adapt, and get along. Saturn demonstrates defined boundaries in its rings, in time, and in matter. Capricorn is the tenth zodiac sign, and represents maturity, wisdom, and faith. Famous Capricorns include Elvis Presley, Martin Luther King Jr., Richard Nixon, Edgar Allan Poe, Benjamin Franklin, Mel Gibson, Stephen Hawking, Muhammad Ali, Betty White, Janis Joplin, Michelle Obama, and Joan of Arc. The Modern Shamanist totem for this sign is the Goose.

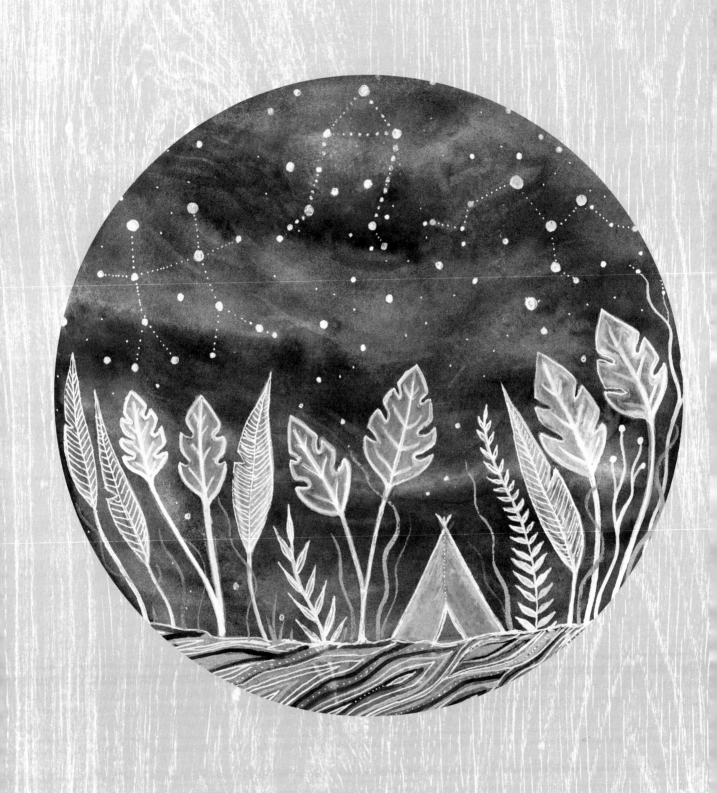

AIR SIGNS

GEMINI LIBRA AQUARIUS

masculine

self-expressive

sanguine (Hippocratic temperament)

communicative

social

conceptual

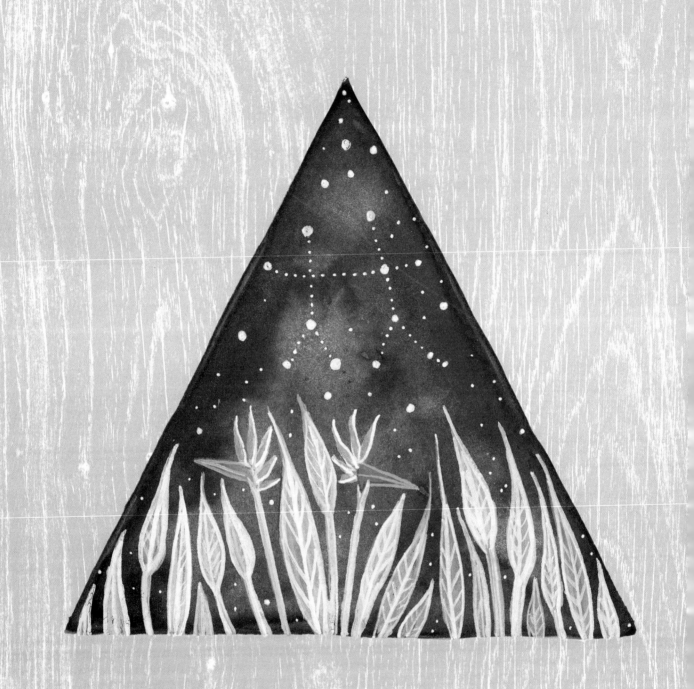

GEMINI: THE TWINS

MAY 21–JUNE 20

Though the term *split personality* is incorrect in psychology, it works well in describing ever-changing Gemini. There are definitely two sides to them—one visible and one hidden. Outwardly, they are quick-witted, smart, cheerful, and charming, but the hidden side is often entirely different. Geminis are glib and vivacious, but also gossipy and nervous; nearly all have a deep need to hide their true motives. Self-expression is critical to them, and they are successful as writers, poets, songwriters, and public speakers. They are also successful salespeople and politicians. This sign rankles at its "twins" label, and is fiercely independent and loathe to ask for help from anyone.

Geminis resist structure and routine; they are adaptable and agile and not afraid to change everything, from their fashion sense to their career. They may change their opinions or belief systems just as quickly. This willingness to jump makes them seem fickle and unreliable. Their facile communication skills can also make them seem shady. Trying to pin down a Gemini in an argument is pointless—the sign is able to talk its way out of any corner. Many will take delight in skewering the opposition and then laugh at their discomfort. Geminis are commonly running late due to their divided attention and disinterest in routines and schedules.

Gemini is the third sign of the zodiac, representing youthful vitality and frivolity. The symbol for Gemini is the Roman numeral two—literally "two joined as one." Gemini is also ruled by mutable Mercury, putting their dual natures frequently at odds with each other. Mercury's status as messenger to the gods demonstrates why the Twins are such successful communicators. Famous Geminis include George Orwell, Ralph Waldo Emerson, Marilyn Monroe, Judy Garland, Bob Hope, Sir Arthur Conan Doyle, John F. Kennedy, Tupac Shakur, Angelina Jolie, Johnny Depp, and Donald Trump. The Modern Shamanist totem for this sign is the Deer.

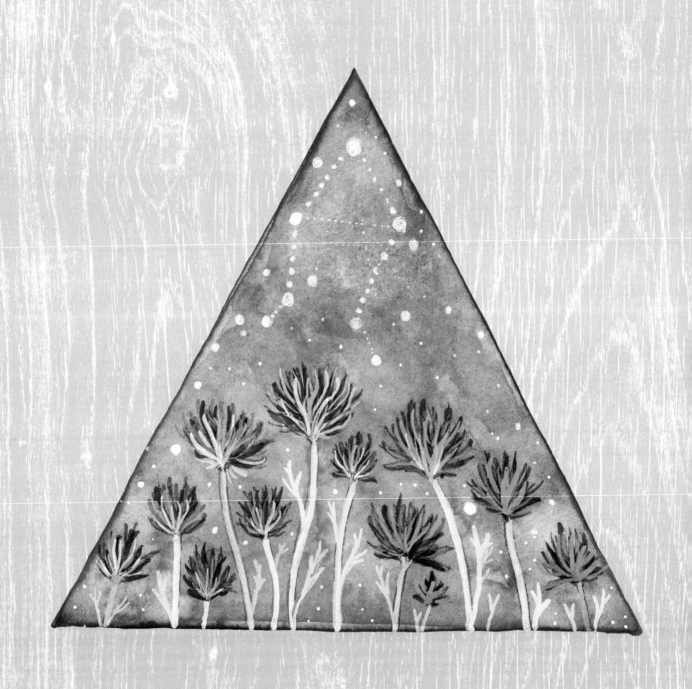

LIBRA: THE SCALES

SEPTEMBER 23–OCTOBER 22

Although sometimes depicted as "Blind Justice" (a blindfolded woman with a sword, holding a balance), in modern practice Libra is more commonly represented by the balance alone, making it the only zodiac sign without a "living" element. Librans are famously just, idealistic, reasonable, and kind. They have strong social skills, are usually well liked, and often have an artistic bent. Librans want to perform work they are passionate about. They excel at justice or diplomatic careers, and are well suited to politics. Their charm allows them to smooth even the most ruffled feathers and create harmony from discord. And no one handles negotiation better than a Libra.

Because of their social grace and charm, much comes easily to Libra and it can sometimes make them egotistical, shallow, careless, or apathetic. Libras vacillate back and forth—like the scale seeking its balance—between loving people, but hating crowds; being good-natured, but sulky; garrulous, but good listeners. If you are emotionally involved with a Libra, you will have to be constantly on your toes due to their shifting moods. They aren't dualities, like Geminis; rather, Librans are always trying to find the middle ground, that perfect balance between white and black, good and bad, right and wrong.

The symbol for Libra is a balance—differing from an actual scale by the use of counterweights—which demonstrates Libra's ability to weigh both sides of an argument to arrive at a fair decision. The ruling planet is Venus, goddess of love and beauty, which gives Librans an air of elegance and sophistication. Venus may also make them prone to overindulgence in food, drink, or even sentiment. Libra is the seventh zodiac sign, and represents fairness, reasoning, and judgment. Famous Librans include Margaret Thatcher, Oscar Wilde, Truman Capote, Brigitte Bardot, Gandhi, John Lennon, Eleanor Roosevelt, William Faulkner, and Desmond Tutu. The Modern Shamanist totem for this sign is the Crow.

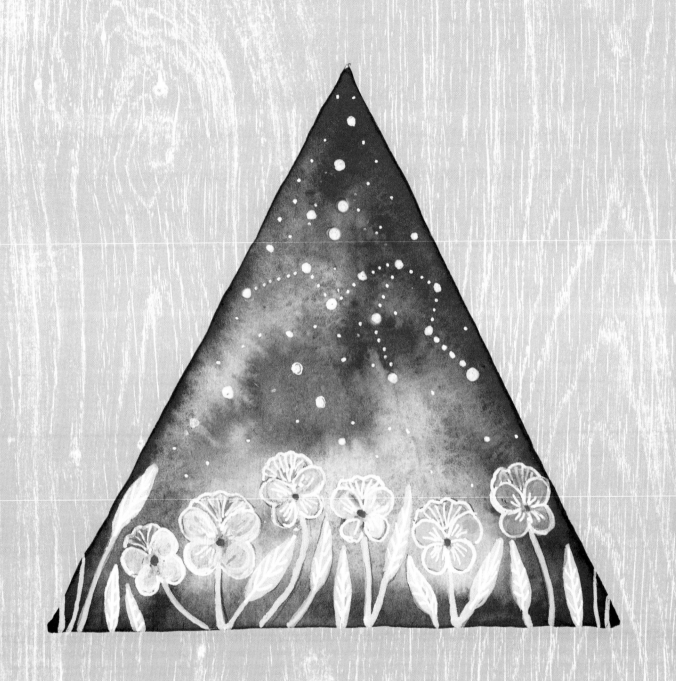

AQUARIUS: THE WATER BEARER

JANUARY 20–FEBRUARY 18

Curiously—although Aquarius is represented by the symbol for waves and its icon is the Water Bearer—Aquarius is considered an air element. Aquarians are unique, smart, and intuitive. They have inquiring minds and are fascinated by politics, puzzles, and people. They are always seeking answers to questions that most of us have yet to think of. Aquarians are "big picture" people; they develop and pursue new ideas and grand visions. Their charitable tendencies and inventiveness make them the zodiac's greatest humanitarians.

Water Bearers love innovation and change. The wave symbol also represents disruption, and Aquarians are all about the next new thing. They are not, however, workaholics and don't really crave materialistic rewards. They want to be passionate in their careers, and are drawn to technology, science, and mathematics, as well as the humanities. They are typically tolerant of other people's inconsiderateness, remaining calm and charitable. They are a sociable group despite a strong independent streak; they are happy in a crowd and have many friends and activities that keep them busy. Water Bearers are extremely perceptive, constantly analyzing and examining. Aquarians have many superficial friendships and lots of "associates," but few deep confidants. Their strong independent streak and insatiable curiosity always have them moving on to the next interesting thing. Many geniuses and iconoclasts are Aquarians.

While Aquarians are idealistic, that idealism is tempered by hard-nosed practicality. Their dreams are not fluttery things. The ruling planet for this sign is Uranus, considered the planet of uprisings and revolutions. Perhaps because of this, Aquarians can be rebellious, hasty, and mutable rule breakers. Aquarius is the eleventh sign of the zodiac, representing a cleansing release of the current material world and a look toward future generations. Famous Aquarians include Oprah Winfrey, Bob Marley, James Dean, Charles Darwin, Charles Dickens, Norman Rockwell, Thomas Edison, and Alicia Keys. The Modern Shamanist totem for this sign is the Otter.

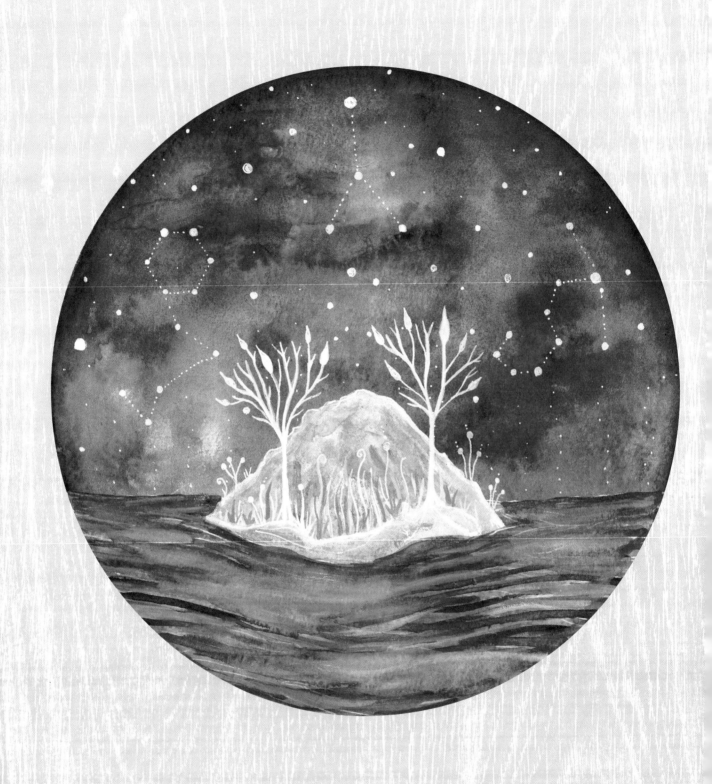

WATER SIGNS

CANCER SCORPIO PISCES

feminine

self-containing

phlegmatic (Hippocratic temperament)

emotional

sensitive

empathic

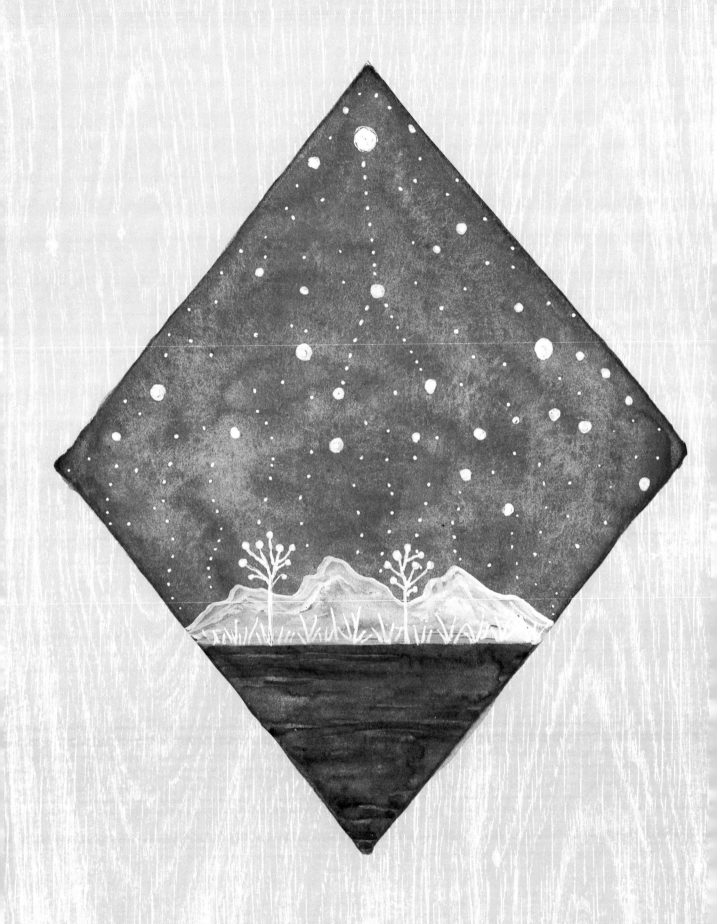

CANCER: THE CRAB

JUNE 21–JULY 22

This sign commonly begins on the summer solstice, the longest day of the year. Cancer people are known to be careful, dedicated, gentle, and kind. They care deeply about people and about issues they hold dear. The Crab will also hold on tenaciously to things they have claimed as their own—material or ideological. They are imaginative and dedicated employees who persevere until they get the job done. They need to feel like they are helping people or making an impact on people's lives to be happy in their careers.

Emotional connections are extremely important to them. They often find satisfaction in careers in education, health, or childcare. The highly sensitive nature of Cancerians makes them vulnerable to criticism. Crab people may shut down emotionally when they feel attacked. If Cancerians don't get the support and positive feedback they need, they may become possessive, greedy, hypersensitive, and prudish. Cancers' emotional sensitivities lead them toward moodiness, which waxes and wanes like the Moon that rules this sign. But their emotional fluctuations never change their basic personality. These people don't wallow in misery or rage out of control. Eventually, they will return to the kind and compassionate people they are. Crabs have a wicked sense of humor, which they often use as a defense mechanism against hurt or wounded pride.

Cancer is the fourth sign of the zodiac, representing nurturing and home. The symbol for Cancer represents not only the claws of the crab, but also connection to both the material and the spiritual worlds. Many Cancerians have a strong "sixth sense," and the group is generally highly intuitive. Cancer's ruling Moon has long been associated with magic and healing; this connection serves to reinforce the mystical aura of Cancer people. Famous Cancerians include the Fourteenth Dalai Lama, Robin Williams, Frida Kahlo, Julius Caesar, Ernest Hemingway, Helen Keller, Tom Hanks, Nelson Mandela, Harrison Ford, Tom Cruise, and Diana, Princess of Wales. The Modern Shamanist totem for this sign is the Woodpecker.

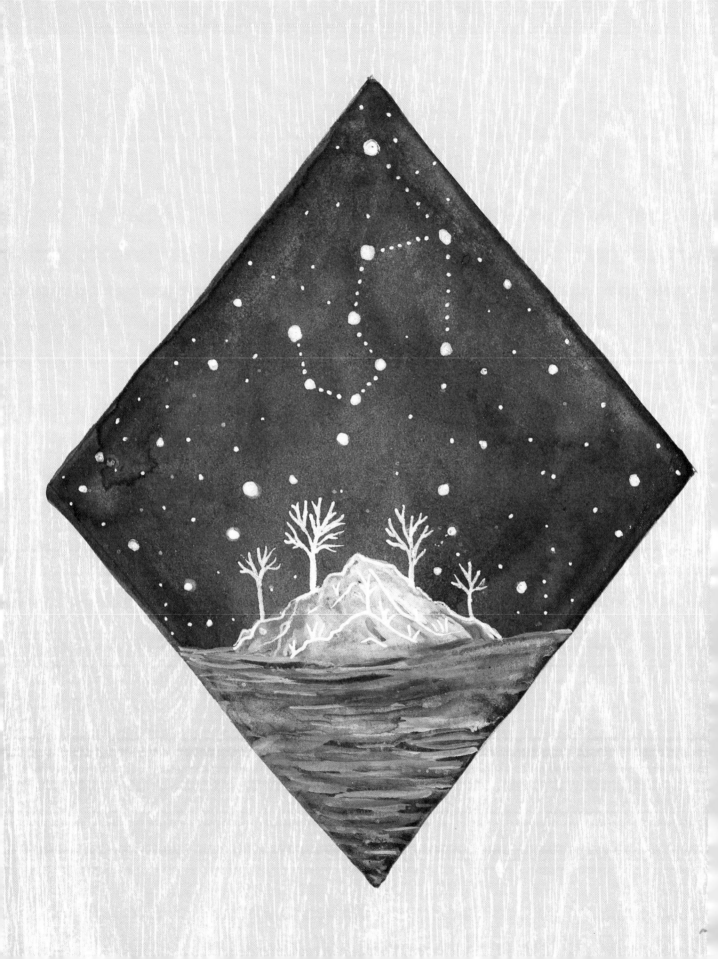

SCORPIO: THE SCORPION

OCTOBER 23–NOVEMBER 21

If there is an enigma in the zodiac, Scorpio is it. These people are complicated, emotionally and intellectually. On the plus side, they are rational, intelligent, devoted, and sensible. They also possess a strong intuitive, insightful, and independent nature. The dark side of Scorpio is suspicious, obsessive, possessive, and willful. They can tend toward arrogance. Scorpios draw a lot of notice in the world, and they love the attention. Scorpion folk are persuasive, mysterious people that hold our attention and leave a deep impression, which may be positive or negative—sometimes both at once. Often, this leads to people feeling uncomfortable around them—uneasy but not sure why. While they thrive on attention, Scorpios are driven by a deep sense of their own personal values. This conflict between public opinion and their "inner voice" may leave them with self-doubts.

Scorpions are often drawn to politics, entertainment, and entrepreneurship. More U.S. presidents have been born under this sign than any other except Aquarius. Courage under fire is a hallmark of Scorpio; many soldiers, firefighters, and police officers carry this zodiac sign.

Scorpios are famous for their robust sexuality, but they kiss and never tell. Do not pry into the private lives of Scorpios; they will not tolerate it. They treasure honesty, and if you ask their opinion you will get it with no holds barred. They are not deliberately cruel; they just don't believe in currying favor. Flattery is largely wasted on Scorpios because, while they enjoy it, they know it isn't real and it fails to move their position on any topic. They attract fiercely loyal followers and create fiercely dedicated enemies. That sense of unease that Scorpios create may make the achievement of their goals difficult for them.

Scorpio is the eighth sign of the zodiac, representing courage, inquisitiveness, and power. The symbol for Scorpio represents the scorpion's stinging tail. Pluto is the ruling body of Scorpio. It is a planet strongly linked to mystery and power, as well as magic. Famous Scorpios include Bill Gates, Marie Curie, Katharine Hepburn, Robert F. Kennedy, Marie Antoinette, Theodore Roosevelt, and Hillary Clinton. The Modern Shamanist totem for this sign is the Snake.

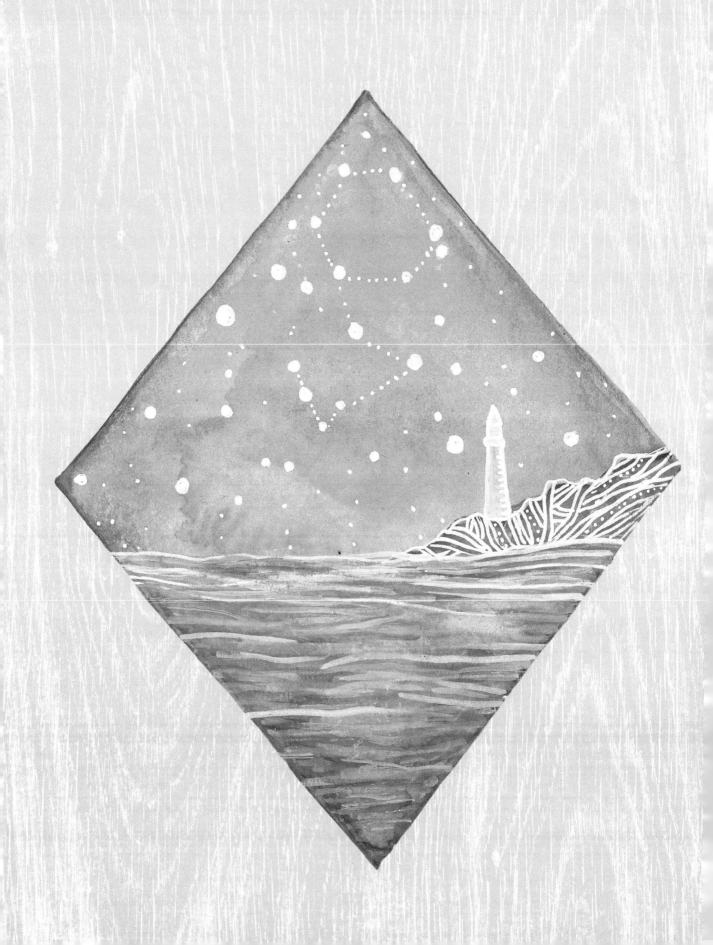

PISCES: THE FISHES

FEBRUARY 19–MARCH 20

Your best buddy in the zodiac may be a Pisces. These folks are friendly, understanding, and great listeners. They have a deep intuition of human emotion and are amazing at reading people. Pisceans are not driven by material gain but by a need for discovery of their surroundings and of other people. They are frequently counselors, therapists, or psychologists, but may also be drawn to exploratory careers like astronaut, astronomer, or oceanographer. Pisceans hate confinement and are commonly found in art galleries, concert halls, author's groups, or libraries. Free-flowing, leisurely pursuits are better suited to them than high-pressure occupations. Pisceans see the intrinsic value of people and things.

Pisceans may tend toward sentimentality and indecisiveness. They are cautious and take their time weighing all factors before making decisions. Their idealism and optimism may make them seem unrealistic, and their giving nature can lead them to be taken advantage of by more forceful personalities.

While fish prefer to go with the flow and let the waves carry them, it is their destiny to fight their way upstream against the current. The symbol for Pisces represents two fish, joined but swimming in opposite directions. This demonstrates the choice all Pisceans must make: whether to let life carry them along or to fight their way upstream. Those who choose the fight can truly change the world. Neptune rules Pisces, and is strongly associated with psychoanalysis and dreamy idealism. The deep need to understand is in conflict with the tendency to see the world through a rosy tint. Pisceans are not concerned with the future or the past; they are truly in-the-moment people. It takes a lot to make a Fish angry, and if you manage it they won't stay that way for long.

Pisces is the twelfth zodiac sign, and represents change, death, and eternity. The deeds of many Pisceans will truly live forever. Famous Fishes include Albert Einstein, George Washington, Michelangelo, Alexander Graham Bell, Victor Hugo, John Steinbeck, Aretha Franklin, Spike Lee, and Elizabeth Taylor. The Modern Shamanist totem for this sign is the Wolf.

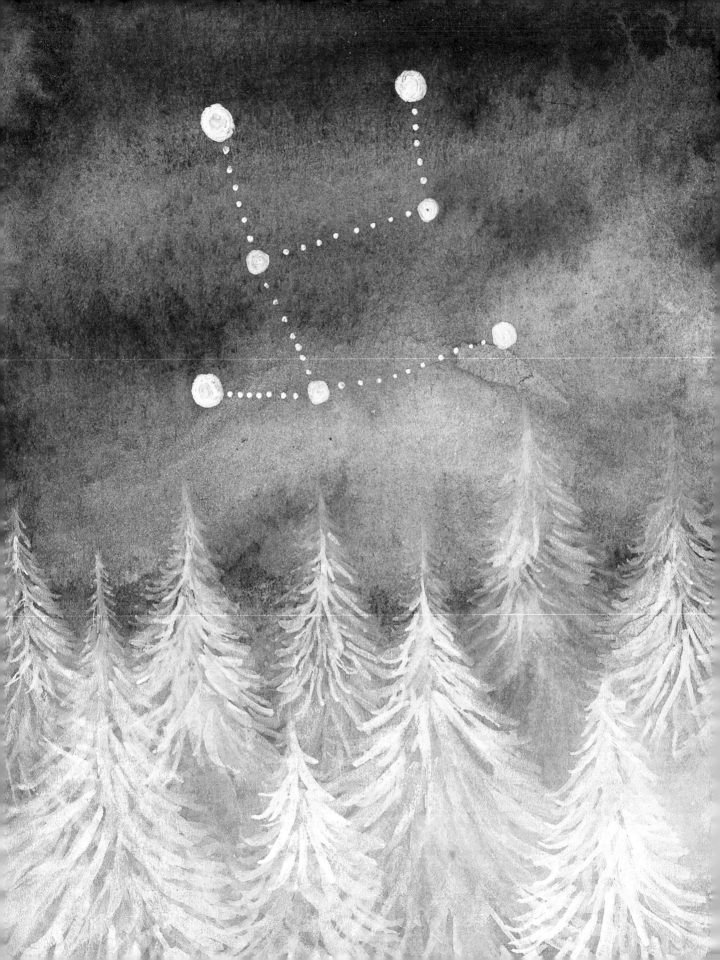

Painting Astrological Watercolors

In the following two step-by-step projects we will paint two astrological paintings. I like to look at reference photographs for my botanical elements, so I have a file of photos I have taken over the years to look at when I need to get the texture of a pine tree just right, or if I have a specific shape in mind for a mountain that I once traveled to.

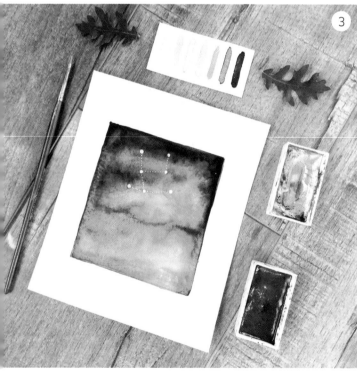

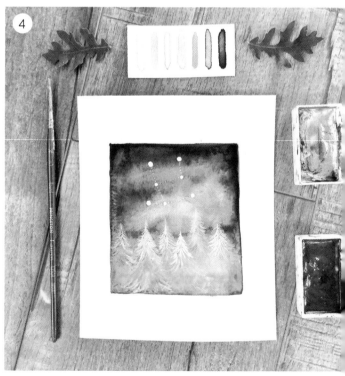

AN ASTROLOGICAL WATERCOLOR

1. Choose your desired paper size, and cut it down with room to spare for framing if necessary. Tape off the edges for a square-, triangular-, or rhombus-shaped painting, or use a compass or any round object as a template for a circular painting. Once this is complete, you can sketch out your preliminary landscape.

2. Once you have your sketch the way you want it, choose your color palette. For this zodiac painting, I chose greens. I used a two-tone gradient wash with viridian green and a small amount of gold metallic watercolor. I let my wash dry completely before I begin the next part of my painting. I generally like to have several paintings that I work on in rotation, so that while one is drying, I can work out the details of another.

3. Once your first wash layer is dry, decide whether it needs a second layer or whether you like the effect achieved from your wash. For the most part, I am never satisfied with that first wash, as it really is just an underpainting to give a sense of where I want the lights and darks in my painting. I go back into my sky and use this second layer to add darker tones and metallics, and I fix anywhere in my painting where the paint dried inconsistently or spread in a way I didn't intend.

4. Once the second layer is dry, begin building up mountains and trees. You should still have a faint trace hiding under your wash layers of the initial pencil sketch of any mountains or trees you made. I find those marks and go back into them with my chosen color. For this painting, I went with white, snowy-looking pine trees with no mountains. I kept my sketch very minimal, knowing I would go back with a gel pen and my 000 round brush for the trees. I start with a lighter white (add more water) for the background trees, and as they move forward, I use brighter white (very little water) to achieve a more dynamic landscape. I go back in with a gel pen to get more detail once my trees are dry. My final details are the stars and constellations. I go back in with a small round 000 brush and white paint, or a white gel pen, for these as well.

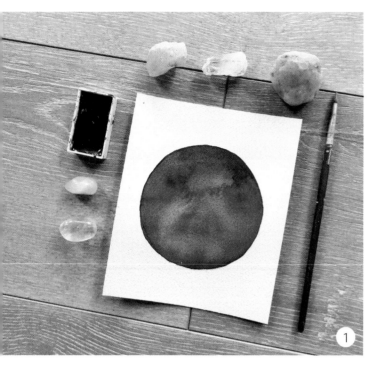

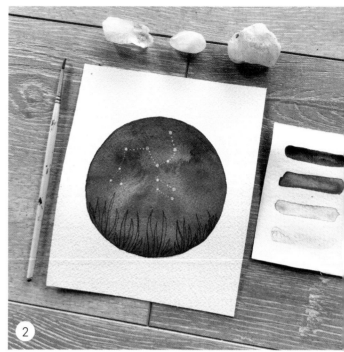

ASTROLOGICAL VARIATION

1. First, decide which color to lay down for your background. I chose a deep magenta for this zodiac sign. Add deeper shades to the edges to make the painting pop.

2. Once the first layer has dried, go back in once more and add a second layer of paint, but this time add more water so as not to completely blot out the first layer. Once you are happy with the sky, it's time to sketch the zodiac sign. Once the stars are dry, lay out any botanical details with a pencil.

3. Now, go over the lines with a light, white paint, and then let dry. At this point, go back into the sky and add more stars.

4. Once the first layer of the plants has dried, go back in with a 000 brush and add any final details. Add a brighter white to any stars in the sky that need it, and then let dry.

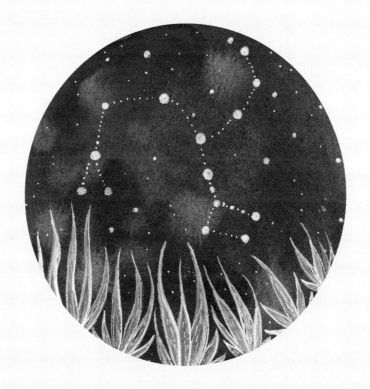

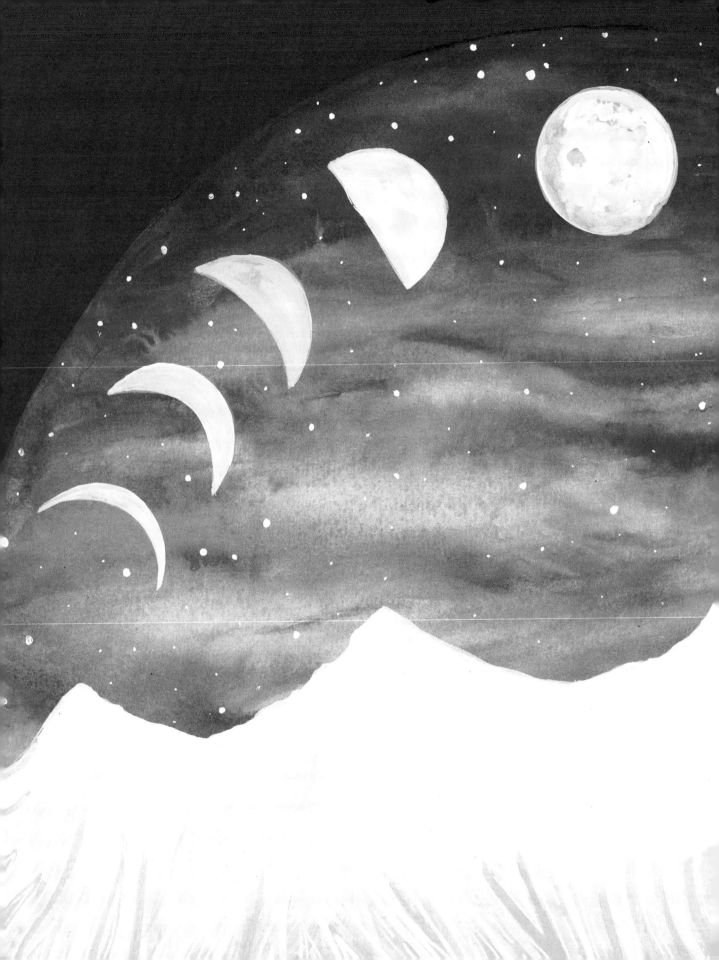

3

The Moon

The exact origins of the moon are a topic of intense debate among astronomers. Some feel that the moon is a piece of the Earth that was broken off when an object the size of Mars hit the Earth about 4.5 million years ago; others believe that the moon is actually a piece of the object itself. And some feel that the truth lies in the middle: that the moon is an amalgam of both the Earth and the celestial body that crashed into us.

We know from Apollo missions that the composition of rocks brought back from the moon is nearly identical to the composition of Earth's elements. However, a few elements are different enough to give credence to the amalgam theory. Regardless, since ancient times the moon has been imbued with extraordinary mystical powers.

The word moon comes from the Greek *menos*, meaning "power." In times when people lived in harmony with nature, the changing seasons were often the focus of secular and religious practices. Moon phases played heavily in these practices, as the different phases were believed to be auspicious for certain activities. Typically, the greater the moonlight visible, the more power it was believed to have. New moons (also called dark moons) were also portentous. Because the effects of the moon on the tides of Earth were visible—and strongest at full and new moons—it is understandable where this idea came from.

La Bella Luna, Queen of the Night: there are many different cultural names for the moon. In a number of these, the moon is referred to as the female/goddess figure; *menos* is also the root of the word *menses*. To the ancient Romans, she was Luna; to the Gaels and Gauls she was Gaia or Galata; the Brits referred to her as Metra (Mother). "Old Woman Who Never Dies" is a common name for the moon in numerous Neolithic societies, including Native American and First Nations tribes.

Native American tribes share similar, but not identical, mythologies with each other. The Sioux name for the moon goddess is Hanwi (meaning "night sun"). There are six different major languages spoken by the various Iroquois tribes. The Cherokee, whose language roots are in the Iroquois group, utilize the same word for the sun and the moon: Nvda. The Mohawk refer to the moon as Ehnita (the Eternal One). The Choctaw, a Muskogean family language tribe, also utilize the same word for the sun and the moon: Hvshi. And the Hawaiian Polynesians call their moon goddess Mahina.

The moon is not, however, always feminine. In Norse mythology, the moon god was Máni (from whence we get the word *maniac*). To them, he was the brother of the sun Sól. These are just a few of the hundreds of names for the moon.

The moon rotates on its axis at the same time it orbits the Earth. This is why we always see the same side of the moon. While Western culture typically describes the moon's face as The Man in the Moon, other cultures, such as Asian, Aztec, and Buddhist, tell of a rabbit or hare. Research supports a number of "myths" we associate with the full moon:

MOON PHASES

WANING GIBBOUS/
DISSEMINATING

Waning means that the visible face of the moon is getting smaller. In different locations on Earth, this may happen from the left, the right, the top, or the bottom.

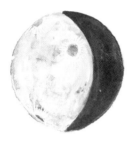

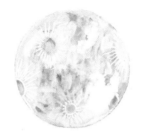

FULL

Full face of the moon is visible; spring tides occur.

WAXING GIBBOUS

Gibbous means the lighted shape of the moon is greater than half but less than the full moon.

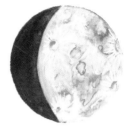

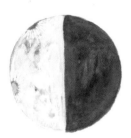

LAST QUARTER/
SECOND HALF

"Quarter" moons refer to the portion of its orbit that the moon has completed around the Earth; the opposite half of the moon is now visible. Neap tides occur.

FIRST QUARTER/
FIRST HALF

Though called first quarter, the visible moon is actually half lit; "neap tides" (smallest difference between high and low tides) occur now.

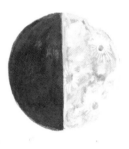

NEW/DARK

"Spring tides" (largest difference between high and low tides) occur now.

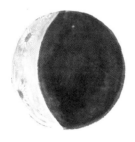

WANING CRESCENT/
BALSAMIC

The moon can only reflect light; it has no light of its own. Sometimes sunlight that bounces off Earth's atmosphere makes the dark part of the moon visible. This is known as "earthshine."

WAXING CRESCENT

Waxing means the lighted part of the visible moon is growing; "earthshine" may make the dark part of the moon visible.

Note: Diagram depicts the moon phases from a Northern Hemisphere perspective.

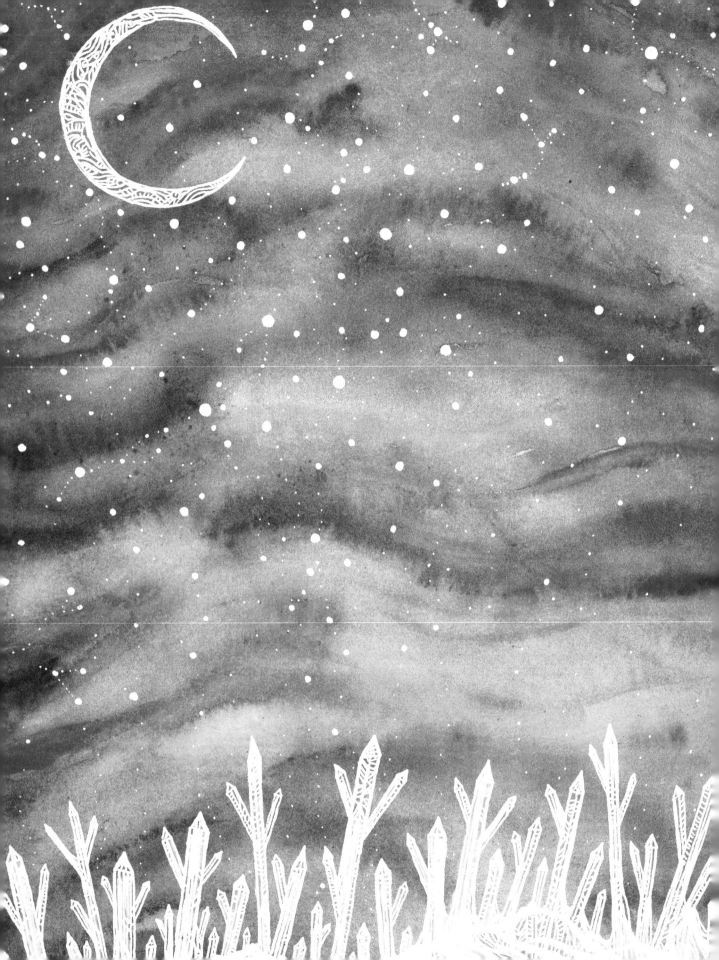

Admissions to psychiatric facilities increase (80 percent of mental health professionals believe the moon affects the mind); the murder rate triples; more drunk driving incidents and crashes occur; hospital ER visits increase 10 percent; and acts of arson increase 100 percent.

Animals and plants are similarly affected by the moon. Herbivores ovulate and corals mate on the full moon. Caribou and salmon migrate; birds use the moon to navigate during their extended migrations. In plants, the measurable electrical charge in cells rises dramatically. The phases of the moon are firmly established in science and folklore. The moon is subject to all kinds of amazing phenomena. A supermoon happens when the full moon occurs at the point in the moon's orbit where it is *closest* to Earth. The moon appears extremely large and bright in the sky. This phenomenon may occur during the new moon as well, but we don't notice it because the moon is dark. A micromoon, on the other hand, happens when the full moon occurs at the point in the moon's orbit where it is *farthest* away from Earth. We use the term *blue moon* to describe an event that happens only rarely and is extraordinary. A blue moon happens when two full moons occur in the same month; truthfully, this event occurs approximately every two and a half years, so it is not especially rare or extraordinary! A harvest moon is the full moon that occurs closest to the autumnal equinox (September 22, in most years). The harvest moon is the only moon defined by its proximity to an equinox. This moon is often orange or reddish due to dust in the atmosphere.

A blood moon is the result of an *eclipsed* moon appearing red due to the dilution and filtering of sunlight through Earth's atmosphere. A lunar eclipse is caused when the Earth passes between the sun and the moon, blocking the sunlight and throwing the Earth's shadow across the moon's face. A solar eclipse will occur two weeks later when the moon and the Earth have switched places, and the moon now blocks part of the sun's light from reaching Earth's surface. During the solar eclipse, the moon's shadow will be cast onto the Earth.

Many religious holidays are linked to moons. For example, Easter is determined to be the first Sunday after the first full moon that follows the vernal/spring equinox. This is why the date on which Easter falls changes from year to year. Likewise, Passover begins on the fifteenth night after the first full moon that follows the vernal equinox. In Islam, the holy month of Ramadan traditionally begins with the visual sighting of the first crescent moon following the new moon. Each new moon marks the beginning of a new month, and Ramadan is the ninth month of the Islamic calendar.

In many cultures, the full moons in each month are given names that describe either the environment in the month of that full moon or the activities that are typically performed during that time. For example, to the Algonquin tribes, the full moon in December was known as the Cold Moon, because the weather was frigid in that month in what is now the northeastern United States. The Sioux tribes referred to the December full moon as When Deer Shed Their Horns.

The following pages display a list of selected cultures across the world and some of the names each had for the various full moons in every month. The Native American tribes were selected as representative of the many and varied tribal names in use; Sioux and Cherokee have the largest number of tribal members in the United States. Algonquin initially provided the most commonly used moon names in the early days of European settlements, and was the basis for the names used in the *Old Farmer's Almanac*. Inuit, rarely thought of when we consider Native American tribes, is included here; Chinese culture is ancient and provides beautifully poetic moon names. The Ogham/Celtic Tree calendar actually features thirteen months rather than twelve. This calendar allegedly originated in ancient times, well before the Druids assigned magical properties to the different tree species of Ireland. It is the most mystical of the represented calendars.

I have adapted the Ogham Tree moons to fit in the twelve-month year. Because the Ogham months begin in approximately the third week of our standard month, the names do not necessarily correspond exactly.

In many cases, lunar months that were previously traditional were radically changed by the introduction of the Gregorian calendar in 1582. This calendar provided for only twelve months rather than the lunar year's thirteen months. The changes have caused some traditional names to seem out of sync with their associated seasons.

WOLF MOON
January

SNOW MOON
February

WORM MOON
March

PINK MOON
April

FLOWER MOON
May

STRAWBERRY MOON
June

BUCK MOON
July

STURGEON MOON
August

CORN MOON
September

HUNTER MOON
October

BEAVER MOON
November

COLD MOON
December

WOLF MOON

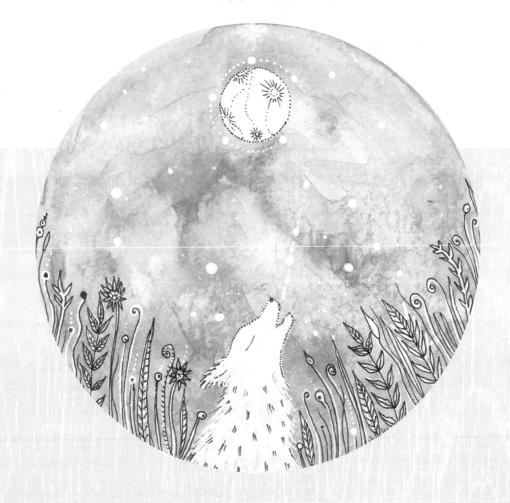

MONTH: January

SIOUX TRIBE: Wolves Run Together

CHEROKEE TRIBE: Cold

ALGONQUIN TRIBE: Wolf

INUIT TRIBE: Dwarf Seal

OGHAM TREE TRADITION: Birch

CELTIC TRADITION: Quiet or Stay Home

OLD ENGLISH TRADITION: Old

CHINESE TRADITION: Holiday

SNOW MOON

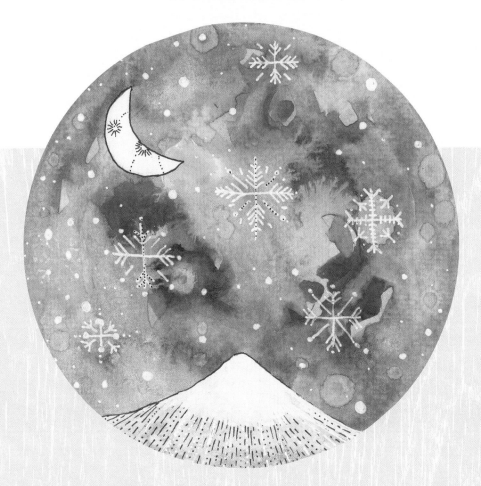

MONTH: February

SIOUX TRIBE: Dark Red Calves

CHEROKEE TRIBE: Boney

ALGONQUIN TRIBE: Snow

INUIT TRIBE: Seal Pup

OGHAM TREE TRADITION: Rowan

CELTIC TRADITION: Ice

OLD ENGLISH TRADITION: Wolf

CHINESE TRADITION: Budding

WORM MOON

MONTH: March

SIOUX TRIBE: So–re Eye

CHEROKEE TRIBE: Windy/Strawberry

ALGONQUIN TRIBE: Worm

INUIT TRIBE: Snow Bird

OGHAM TREE TRADITION: Ash

CELTIC TRADITION: Wind

OLD ENGLISH TRADITION: Lenten

CHINESE TRADITION: Sleeping

PINK MOON

MONTH: April

SIOUX TRIBE: Red Grass Appearing

CHEROKEE TRIBE: Flower

ALGONQUIN TRIBE: Pink

INUIT TRIBE: Snow Melt

OGHAM TREE TRADITION: Alder

CELTIC TREE TRADITION: Growing or New Shoots

OLD ENGLISH TRADITION: Egg

CHINESE TRADITION: Peony

FLOWER MOON

MONTH: May

SIOUX TRIBE: When Ponies Shed

CHEROKEE TRIBE: Planting

ALGONQUIN TRIBE: Flower

INUIT TRIBE: Goose

OGHAM TREE TRADITION: Willow

CELTIC TRADITION: Bright

OLD ENGLISH TRADITION: Milk

CHINESE TRADITION: Dragon

STRAWBERRY MOON

MONTH: June

SIOUX TRIBE: Strawberry

CHEROKEE TRIBE: Flower

ALGONQUIN TRIBE: Pink

INUIT TRIBE: Snow Melt

OGHAM TREE TRADITION: Alder

CELTIC TRADITION: Growing or New Shoots

OLD ENGLISH TRADITION: Egg

CHINESE TRADITION: Peony

BUCK MOON

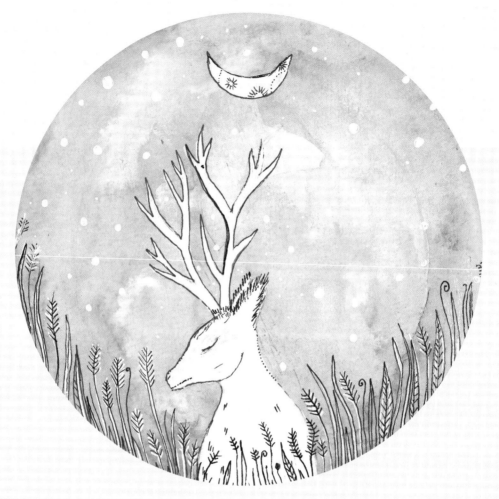

MONTH: July
SIOUX TRIBE: Red Blooming Lilies
CHEROKEE TRIBE: Ripe Corn
ALGONQUIN TRIBE: Buck
INUIT TRIBE: Dry
OGHAM TREE TRADITION: Oak
CELTIC TRADITION: Claiming
OLD ENGLISH TRADITION: Hay
CHINESE TRADITION: Hungry Ghost

STURGEON MOON

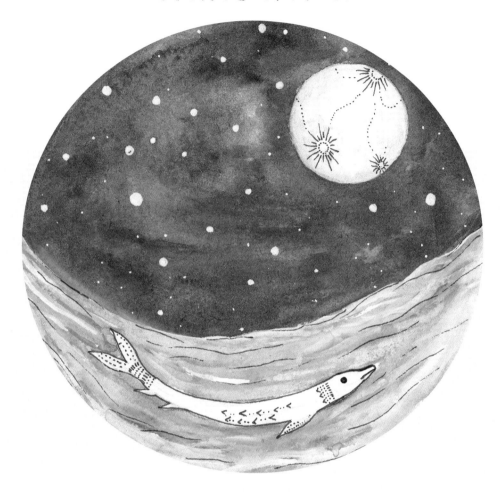

MONTH: August

SIOUX TRIBE: Cherries Turn Black

CHEROKEE TRIBE: Fruit or Drying Up

ALGONQUIN TRIBE: Sturgeon

INUIT TRIBE: Swan Flight

OGHAM TREE TRADITION: Holly

CELTIC TRADITION: Dispute

OLD ENGLISH TRADITION: Grain

CHINESE TRADITION: Harvest

CORN MOON

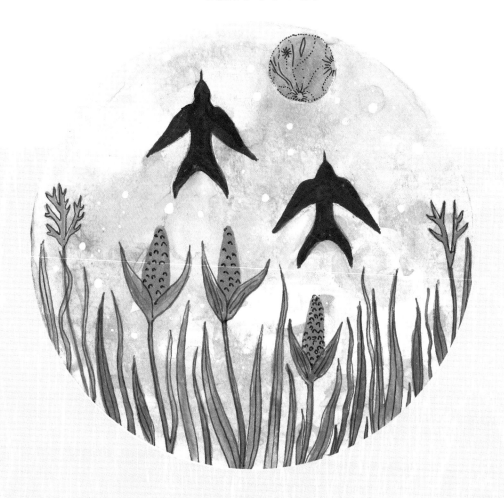

MONTH: September

SIOUX TRIBE: Calves Grow Hair

CHEROKEE TRIBE: Nut

ALGONQUIN TRIBE: Harvest

INUIT TRIBE: Harpoon

OGHAM TREE TRADITION: Hazel

CELTIC TRADITION: Song or Singing

OLD ENGLISH TRADITION: Fruit

CHINESE TRADITION: Chrysanthemum

HUNTER MOON

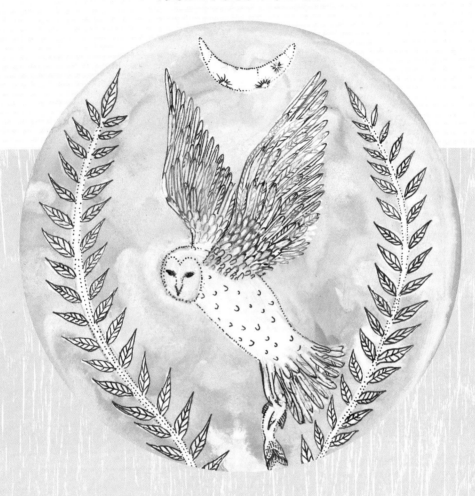

MONTH: October

SIOUX TRIBE: Changing Season

CHEROKEE TRIBE: Harvest

ALGONQUIN TRIBE: Hunter's

INUIT TRIBE: Ice

OGHAM TREE TRADITION: Ivy

CELTIC TRADITION: Blood

OLD ENGLISH TRADITION: Harvest

CHINESE TRADITION: Kindly

BEAVER MOON

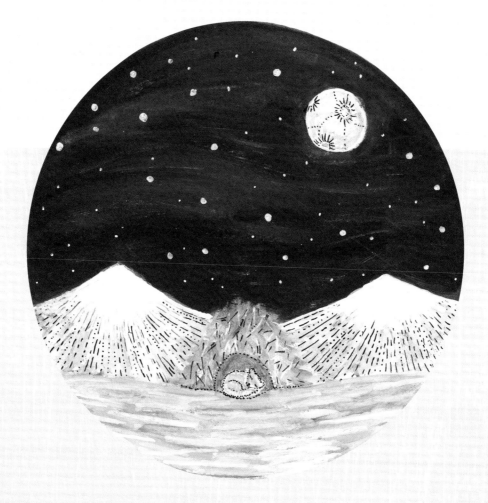

MONTH: November

SIOUX TRIBE: Falling Leaves

CHEROKEE TRIBE: Trading

ALGONQUIN TRIBE: Beaver

INUIT TRIBE: Freezing Mist

OGHAM TREE TRADITION: Reed

CELTIC TRADITION: Dark or Darkest Depths

OLD ENGLISH TRADITION: Hunter's

CHINESE TRADITION: White

COLD MOON

MONTH: December

SIOUX TRIBE: Deer Shed Their Horns

CHEROKEE TRIBE: Snow

ALGONQUIN TRIBE: Cold

INUIT TRIBE: Dark Night

OGHAM TREE TRADITION: Elder

CELTIC TRADITION: Cold or Oak

OLD ENGLISH TRADITION: Oak

CHINESE TRADITION: Bitter

Moon Lore

No discussion regarding the moon is complete without talking about moon lore. This subject includes not only the "myths" associated with the full moon, which we talked about earlier, but also the moon's connection to mythology and various "craft" traditions. Followers of Wicca, Druidism, witchcraft, and other pagan and neo-pagan philosophies often perform their rites and celebrations in accordance with the moon's phases. The spring festival of Beltane is often held during the first full moon in May. This festival may alternatively be celebrated when the constellation Pleiades can be seen on the dawn horizon. As is typical, celebrations linked to astronomical icons shift as those icons change position.

The summer and winter solstices are considered sacred days by many, and are marked by great gatherings in nature or "vortex" locations. A vortex, in mystical terms, is a crossing point of the various fields of magnetic energy that circle the Earth. It is said that the energy at these points is greatly amplified, allowing for a number of different spiritual and metaphysical effects. Such vortices are said to occur in places such as Stonehenge in England, and Sedona, Arizona, in the United States.

Just as most cultures have their own names for the various full moons, so too do most have their own unique mythologies. Many of us are familiar with the Greco-Roman gods and goddesses and the stories associated with them. The Greek moon goddess is named Selene; the same goddess has the name Luna in Roman mythology. In large measure, the Romans adopted the Greek traditions and simply gave the deities new Latin names.

While a large number of societies associated the moon with female deities, and the sun with male, notable exceptions exist. The Sumerian Sin/Nanna and Japanese Tsukuyomi/Tsuki-Yomi were masculine moon gods. The complex pantheon of Egyptian divinities included both male (Thoth and Chonsu/Khonsu) and female (Nut and Sefkhet) lunar deities.

While the moon had many names in different cultures across the globe, so too did the constellations. Indo-European cultures know Orion the Hunter, but that same group of stars was described as a giant hand by Lakota tribesmen, a stag by Hindus, a white tiger by the Chinese, and the great sun god Ra by the Egyptians. Ursa Major was a bear to both the Greeks and the Navaho, but represented seven sages in India. The wives of those seven sages took themselves off to form their own constellation, which the Greeks would name the Pleiades.

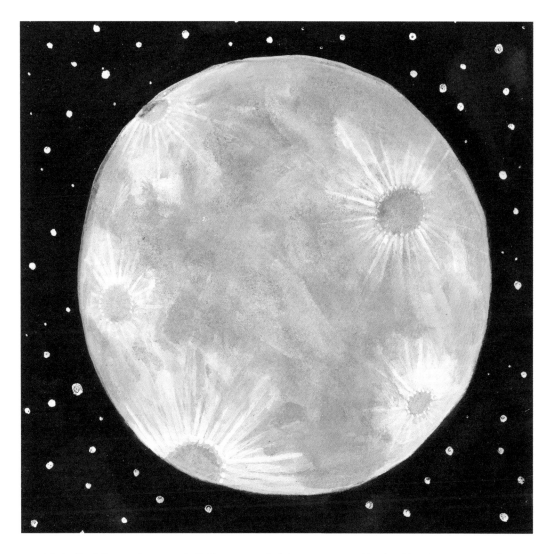

Not all of the major constellations are visible year-round in the Northern Hemisphere. Five that are include Cassiopeia, Cepheus, Draco, Ursa Major, and Ursa Minor. At certain latitudes, even these star groups may dip below the horizon; Ursa Major is typically only visible year-round in the north. New technology, like the invention of the telescope and camera, as well as deep-space exploration, has allowed modern scientists to locate and name star groups not visible from Earth.

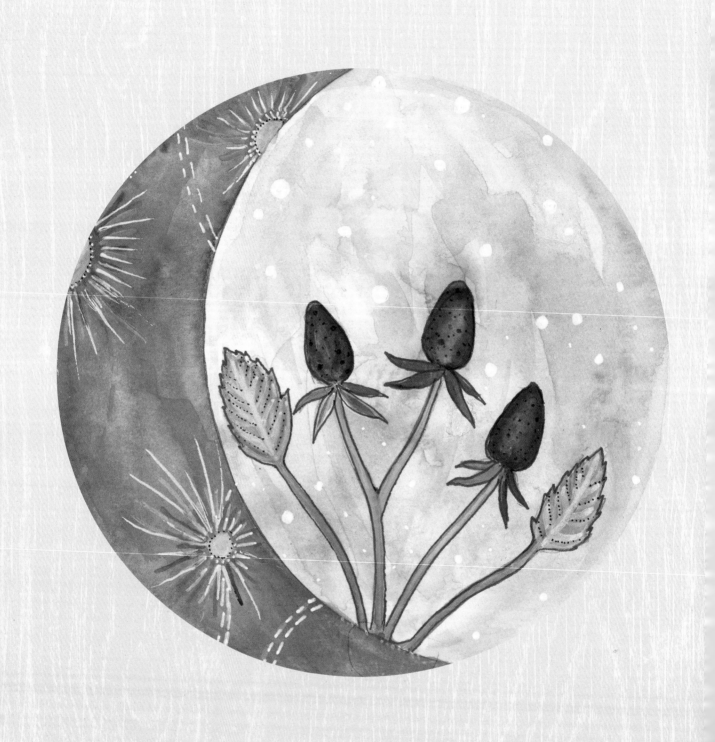

Painting Moon Watercolors

In these next two watercolor paintings, we will paint two moons. In the first painting, I use June's Strawberry Moon from page 89 and mix shades of pink for a rich, textured effect. In the second painting, a variation, mixing gray and metallic silver lends for a shimmering effect.

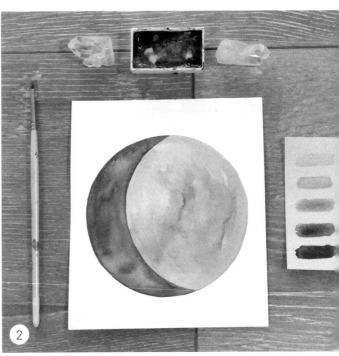

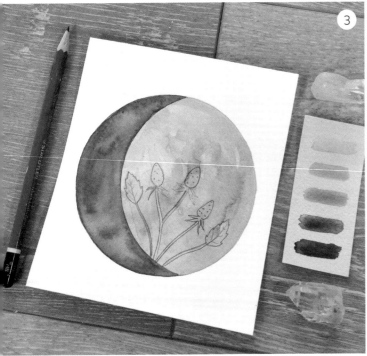

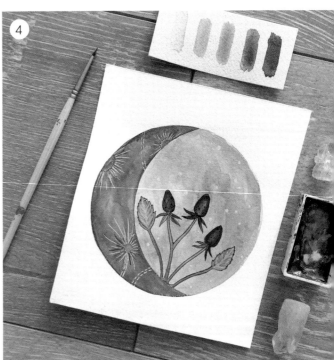

PAINTING A MOON WATERCOLOR

1. Start with your desired paper size and a circular template or compass. Center your template in the middle of your paper and gently sketch out a circle. This will be your guide as you paint your moon. When painting moons, I generally start with my darker colors first, and I edge them around the pencil line to cover it, so that when I add a small amount of water, that pigment will spread into the middle and sides. I take my paint with a very small amount of water and go in with a medium round (4) paintbrush. I go back in with lighter white paint once the darker pigment has been laid down in the areas I want. I also tend to do light round marks where I want my moon craters to be.

2. Once the first layer is dry, I go back into my moon painting with a lighter mixed version of the color I started with. For example, if I start with a deep pink, I mix a slightly lighter version of that pink, and add that to create depth and luminosity in my moon. Once that layer has been added, I go into the painting again with an even lighter pink, and I blend this with any darker pink areas that need an extra layer or more detail.

3. I use this step to add any extra paint marks and craters to my moon. Sometimes if I'm not satisfied with any paint marks, or the way an area has dried, I will add just water to a paintbrush and smooth out any rough edges or marks. I then draw my details.

4. Once you have added several shades of color to your moon, it is time to finalize your painting and add details. For this step, I go in with my white gel pen and a 000 round detail brush. I like to add bright white lines to emphasize my moon craters. Once I have done this, and my pen and paint layers are dry, I finalize any details with a Sakura Micron 05 pen, which has a very fine point, and I add tiny lines and dots to make my moon unique and detailed.

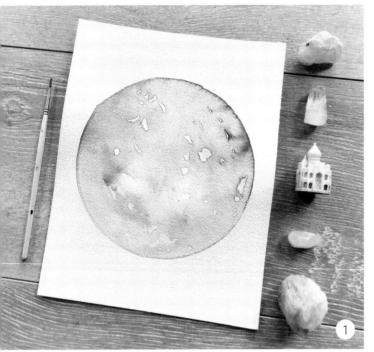

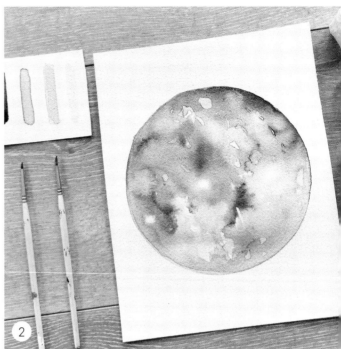

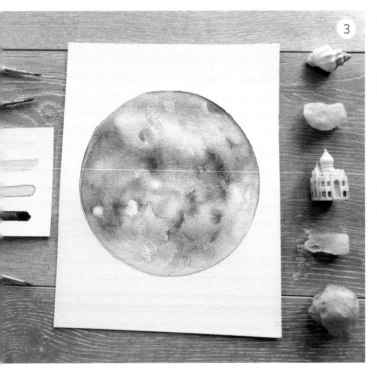

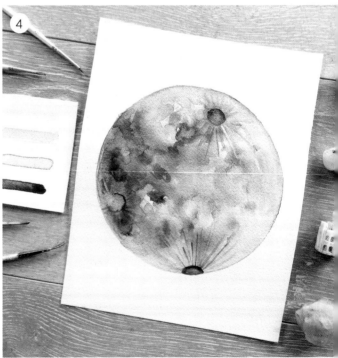

MOON VARIATION

1. First, lay out the circular template with a pencil. Keep the marks light, so that you can cover them easily. Then choose your colors and lay out a light wash. For this moon I chose gray and a bit of metallic silver. Let this layer dry.

2. Once dry, go back in with black paint and define the edges and middle. I added water first and then black paint so that it would spread and blend with the other layer. Let dry.

3. For this step, go in with two brushes, one ½-angle brush and a 000 brush. Use the angle to blend the paint, and a 000 brush to make marks where you want the craters to go. Let dry.

4. Finally, add details. I went back in with a 000 brush and added white and gray lines to the craters. Add any extra detail you want, and then go back in with a small amount of silver paint to highlight.

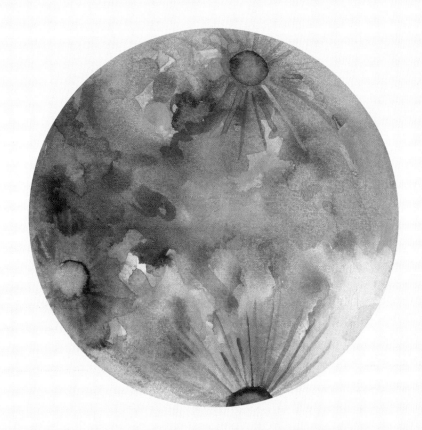

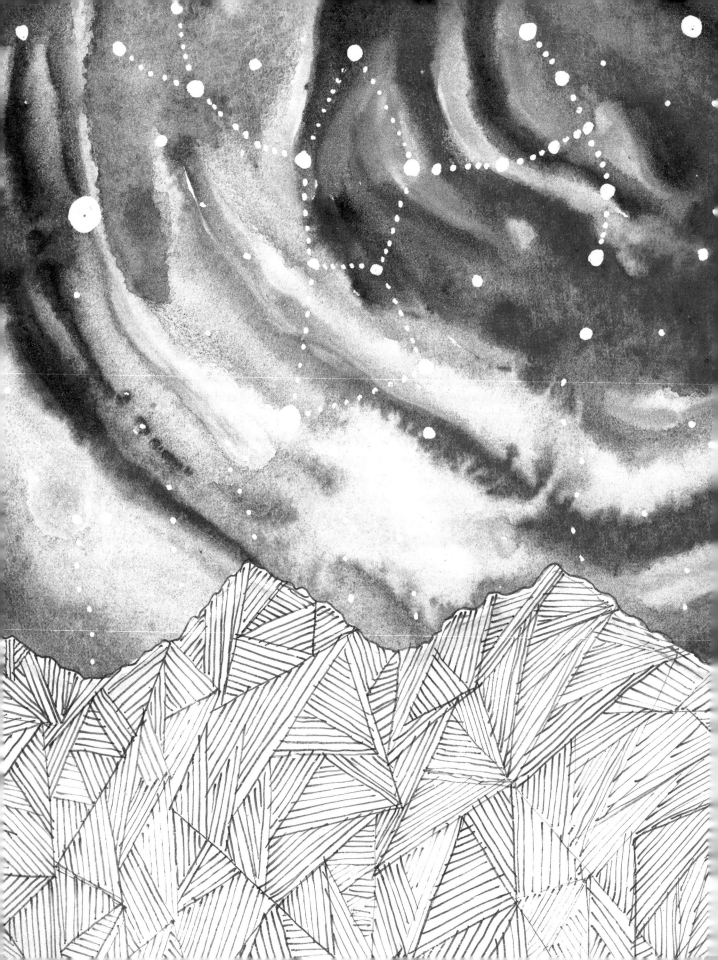

Seasonal Night Sky Landscapes

If you follow the traditional Gregorian calendar, the seasons begin and end on specific dates. For example, summer starts on June 21, while winter arrives on December 21. Modern astronomy can pinpoint the exact time of the arrival of the solstice, but high priests and shamans determined these happenings in ancient times. Often, they would rely on the appearance of particular constellations to determine the change of seasons. While some constellations are visible year-round, others are only visible at certain times of the year in the different hemispheres. In this book, we will confine ourselves to the Northern Hemisphere.

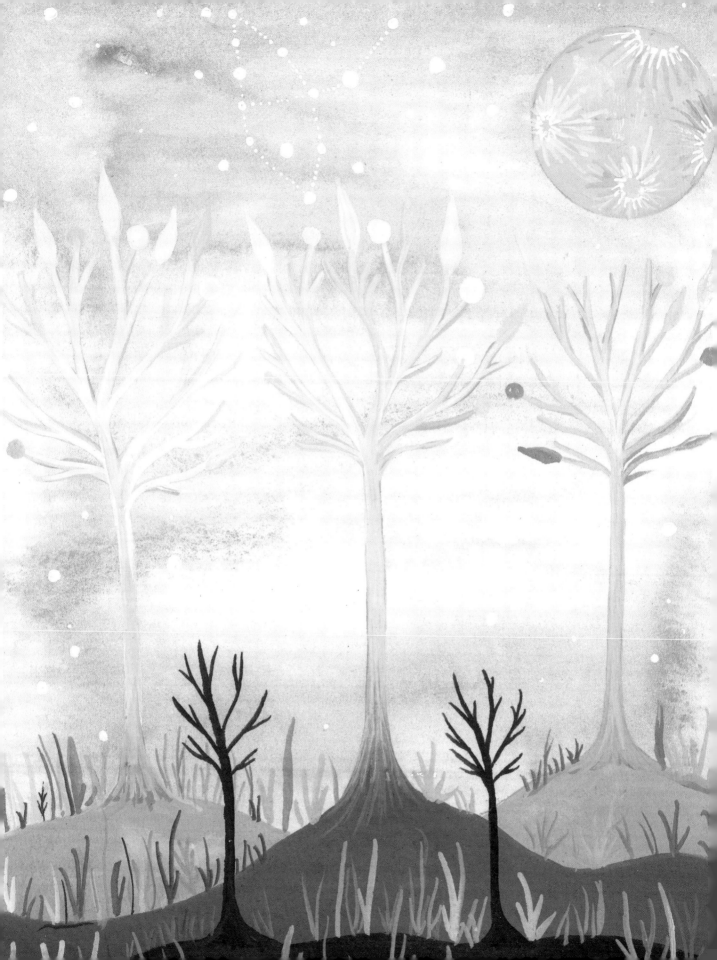

Spring

The astrological constellations visible in the spring night sky are Cancer, Leo, and Virgo. The Earth's axis is at a midway point tilted toward the sun, so temperatures are generally mild. Most animals begin birthing at this time; small creatures mate and deliver their young in a single season, while larger animals will have mated the year before and have their young now. Many plants also begin blooming, and breezy weather scatters their pollen far and wide. Sunlight hits the Earth at an angle in spring, and many of the colors in nature are somewhat muted. Pastels, golden or light greens, and soft browns and beiges are common. Most animal babies arrive with buffy coloring that allows them to remain camouflaged in the still-emerging undergrowth. Neolithic humanity was extremely busy during the spring: crops had to be planted, fresh food gathered, dwellings cleaned out and mended. Many societies prepared for summer migrations that would follow the big game down to their lower-altitude grazing grounds. The moon names of spring reflect these activities: Flower Moon, Worm Moon, Planter's Moon, and Red Grass Appearing Moon.

SPRING COLORS: LIGHT AND BRIGHT PASTELS

For my spring landscape paintings, I use a brighter set of blues and pastel tones, such as cerulean blue, with a small amount of gold metallic pigment in the sky. I also add a variety of flowers and botanical details to give my painting a light, spring vibe.

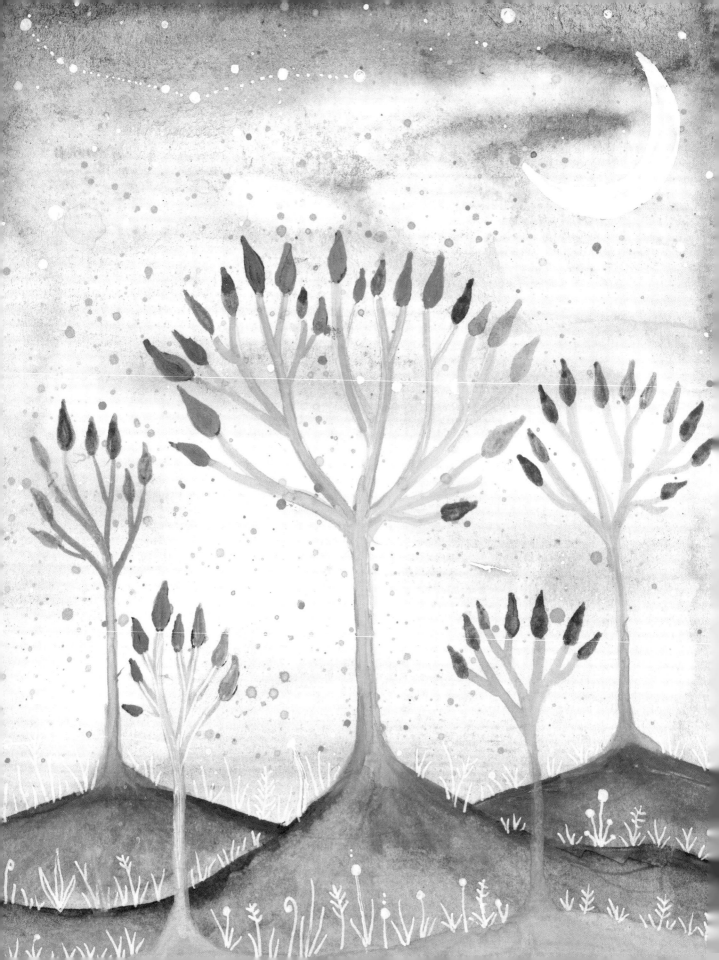

Summer

The astrological constellations visible in summer are Sagittarius and Scorpio. Libra is also a summer constellation, but it is in the Southern Hemisphere and, like the Little Dipper, is often only visible in the southern part of the Northern Hemisphere. The Earth's axis is fully tilted toward the sun now, and the light and heat are much more intense. Nature is in her fullness at this time. Colors are rich and vibrant: emerald greens, ruby reds, and sapphire blues abound, attracting insect pollinators such as bees, butterflies, and night-flying moths. Bats and hummingbirds also contribute. Animal young are fully mobile and are busy feeding and running to pack on muscle and fat before the autumn migrations. Humans are migrating as well, some following the great herds of grazing animals, others traveling to summer gatherings where goods, gossip, and tribal specialties will be exchanged. Young people meet potential new mates while scattered families reunite after months or years apart. New discoveries in crafts, weaponry, and technique are shared to the benefit of all, and life is as easy as it gets in the long days of summer. Moon names now include Rose Moon, Green Corn Moon, Strawberry Moon, and Claiming Moon.

SUMMER COLORS: RICH GEM TONES AND GREENS

For my summer landscapes, I want to achieve a brighter and richer shade of blue and therefore sometimes use cobalt and Prussian blue to bring in a bright and airy quality to the sky. In addition, I focus on summer botanical elements and use greens to give my landscapes a rich summer feeling.

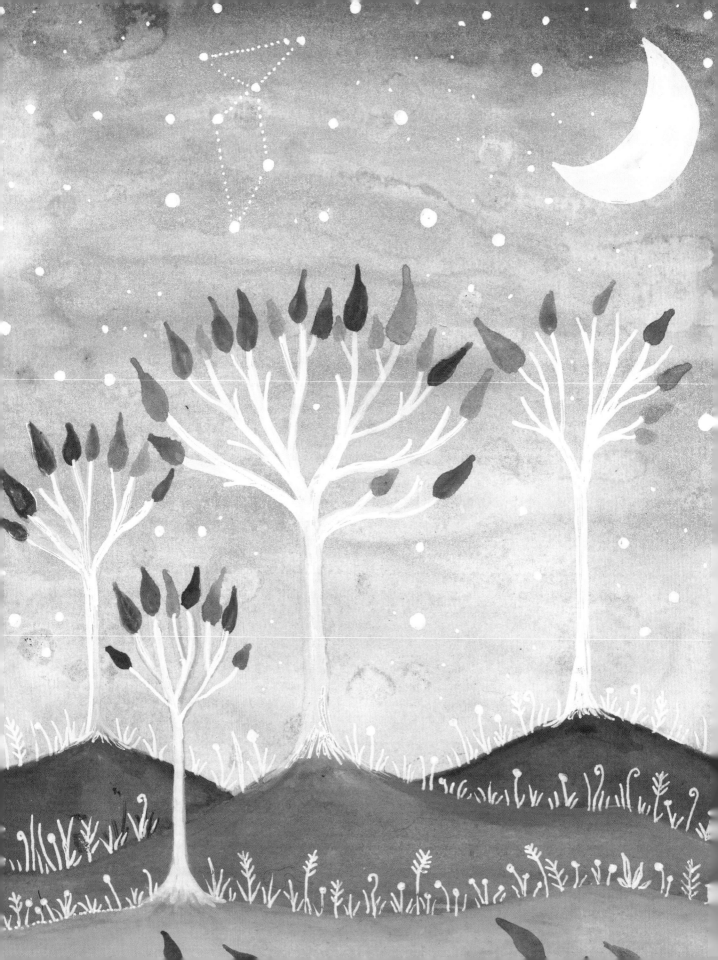

Autumn

Visible in the sky in autumn are the astrological constellations Aquarius, Capricorn, and Pisces. The Earth has begun its axial tilt away from the sun again, and temperatures are cooling off. Plants are the first to react and begin shutting down metabolic processes for their winter dormancy. As nutrients to the foliage lessen, the foliage begins to change color, which varies depending on the plant species. Earth tones of brown, gold, red, and orange flare in a last brilliant display, then become muted and soften as the season progresses. In addition to cooling temperatures, changes in daylight have profound affects. Shortened days trigger the blooming of some plants that take advantage of the lack of competition for pollinators. Fruits and nuts ripen, and grains are harvested. Migrating birds react to the changing light and prepare for their long trips to warmer wintering grounds. They will navigate by the positions of the moon and stars if they fly at night, and by visual cues on the landscape below during the day—led by experienced birds that have memorized the way. The great herds begin moving upland as the summer grass is depleted, and their human shadows follow. Autumn is the busiest time for humanity. Hunts must be conducted and the meat dried or salted to preserve for the winter. Berries, nuts, and grains are dried and stored. Furs are prepped for bedding and warm winter clothing. Lodgings are secured and made sturdy for the loads of snow they may have to bear. These activities and more will continue until the snow becomes too deep and the days too bitter. Moon names include Falling Leaves Moon, Harvest Moon, Nut Moon, and Hunter's Moon.

AUTUMN COLORS: MUTED EARTH TONES AND BROWNS

For my autumn landscapes, I use more muted tones that help portray a dramatic shift in the seasons, from bright and warm to dark and cold. I like to use muted reds and oranges, gold, and yellow tones for fallen leaves throughout my painting to give an autumnal atmosphere.

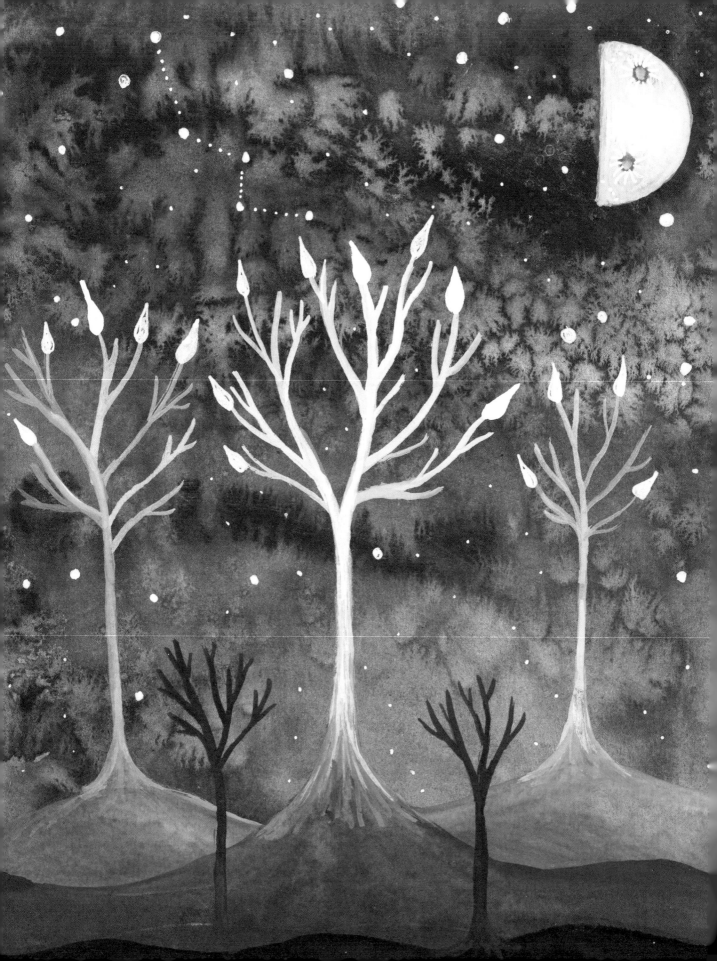

Winter

Constellations in the winter sky include Gemini and Taurus. Aries is not a particularly bright constellation and may be difficult to spot without a telescope. The Earth's axis is now at full tilt away from the sun. Heat and light are at a minimum in the Northern Hemisphere, and temperatures are well below zero in many areas. At the North Pole, the sun never rises; it will stay dark until March. Because the days are shortest at this time of year, color is not easily discernable. Most plants are dormant; those that aren't have slowed their growth dramatically. Evergreens appear nearly black in the gloom, while naked trees trace patterns against the snow on brightly lit winter nights. The moon is most brilliant now; no dust or pollens in the air obscure the view, and the deep dark of night makes the moon's light seem as bright as the sun. The contrast between the luminous snow and the blackened trees is starkly beautiful. Animals may also be dormant. Some hibernate all winter while others cut down on activity to save energy. Food is scarce for grazing animals, but carnivores do well as a result. Humans have hunkered down in their groups, keeping together for warmth and safety. During this time, children will be taught skills they will need as adults: sewing and clothing production, tool making, basketry or pottery arts, and other skills that can be taught indoors are demonstrated. A select few tribal members will learn shamanism from their own religious leader, including skills such as astronomy and medicine. Moon names reflect the hardships of winter: Wolf Moon, Bitter Moon, Snow Moon, and Little Famine Moon.

WINTER COLORS: CLEAR, DEEP TONES AND BLACK-GRAY

For my winter landscapes, I want a cold, almost barren, quality to my paintings. I add trees without foliage and keep my mountains very minimal. I use indigo for my sky to achieve a dense and dark quality, which only the winter season has.

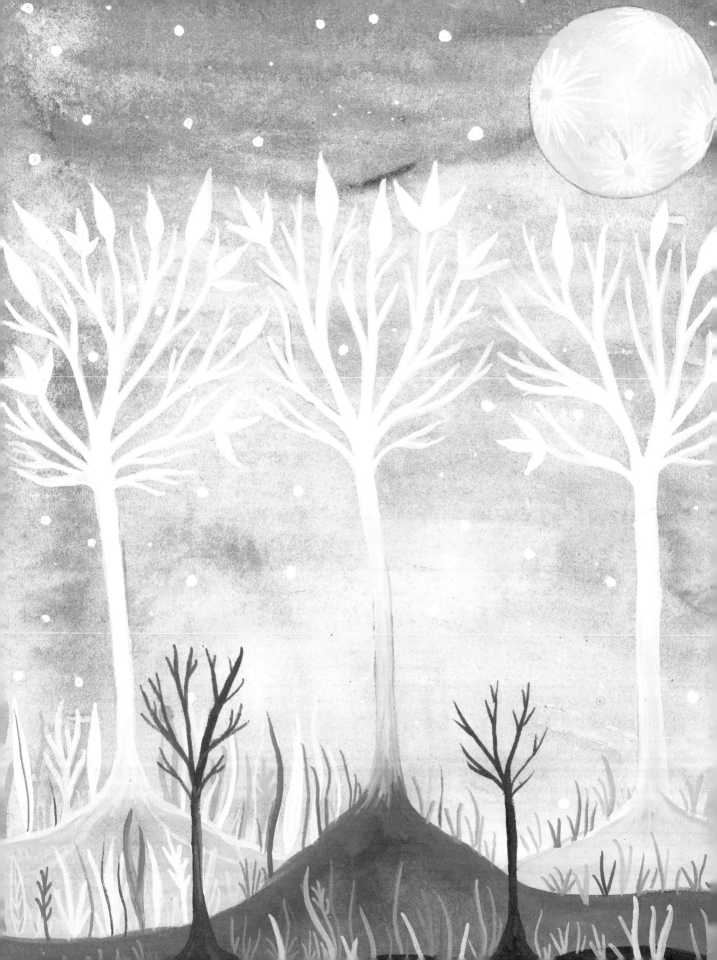

Painting Seasonal Night Sky Watercolors

In this section we will create four seasonal night sky paintings. I have chosen the spring night sky as my first painting, utilizing light blues and pastels in the palette, as well as a lot of white for the botanical details and stars. In the three variations that follow it, I repeat spring's basic night sky composition, but use different colors and elements that correspond to summer, fall, and winter nighttime seasonal palettes to show how different color combinations give nuances.

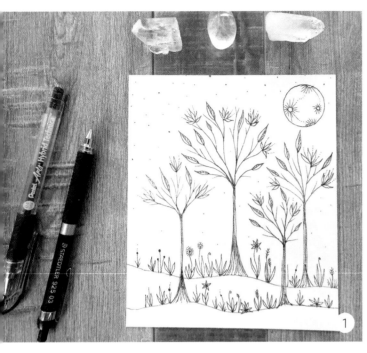

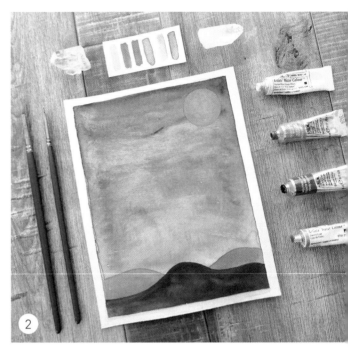

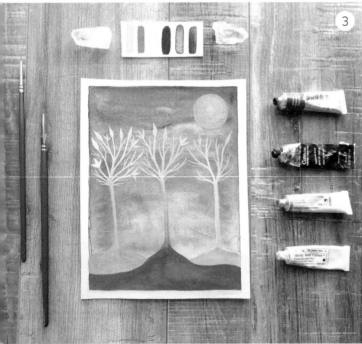

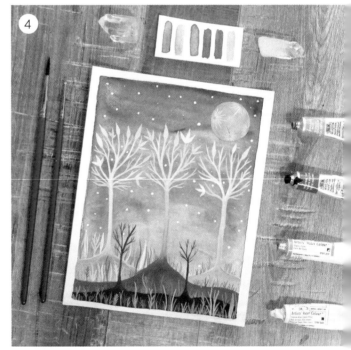

PAINTING A SPRING WATERCOLOR

1. Begin by drawing a rough sketch to see what works and what doesn't. After I make any changes, I move forward with a rough sketch using a light mechanical pencil on the watercolor paper to be certain I like the composition and layout. Sometimes I do a very light wash (mostly water with a very small amount of watercolor paint) over my sketch. It acts as my underpainting and every layer adds more dimension to my sky. I used this technique for both my autumn and my winter sky landscapes (see pages 111 and 113).

2. Go back into the initial sketch and begin to add more color. I use the wet-on-wet technique (see page 31) and first paint a very light watercolor wash and then go back in with a darker paint. Notice how the paint spreads and creates some wonderful textures. You could experiment with the wet-on-dry technique (see page 31) for this step; however, the paint will not spread in the same way and gives a flatter, less variable sky.

3. Allow the painting to dry before starting this step so that the colors do not bleed when adding the main elements—in this example, the mountains and botanical elements. Start with the mountains, moving from light to dark to give depth to the painting. Let each layer dry before continuing. After the mountains, I move to the environmental details, such as plants, trees, stars, and the moon. I usually use a Uni-ball gel pen and a 000 round brush with white watercolor paint for this step.

4. For the final part, take a moment to reflect and evaluate the painting. It is easy to become lost in all the details only to realize you are not happy with an aspect of the painting. I like to hang a painting on a white wall, or on an easel, which allows me to see it in its entirety and decide what needs to be added or subtracted from the composition. If I like where I'm at, I add some extra metallic details with my smallest 000 round brush. I also go in with a Sakura Micron 05 pen and add fine detail to any leaves, flowers, the sky, or anywhere else I feel might need a little refinement.

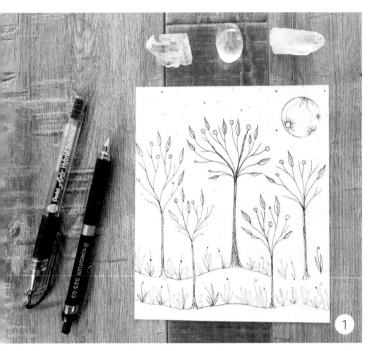

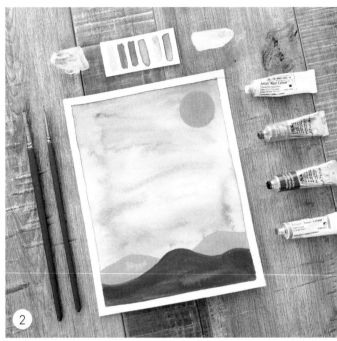

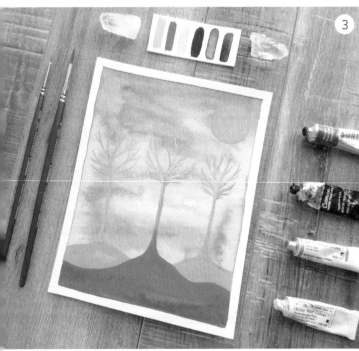

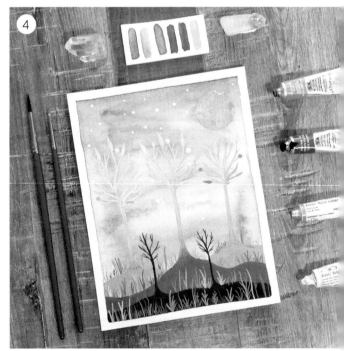

SUMMER VARIATION

1. First, sketch out the details you want in the landscape. Keep the pencil marks fairly light, so that you can cover any marks with a wash in the next step.

2. Then, paint the first wash layer of the sky. For summer, I chose a cerulean blue and tinted it with a small amount of white paint. Let it dry.

3. Go back into the trees and foliage, and add a light white to everything. Let this layer dry. Add stars at this stage as well, and any other celestial bodies, such as moons, galaxies, etc. that you want in the painting.

4. Work on the final details of the painting. Go over the botanical elements with a 000 brush and work on the details, such as branches, leaves, etc. For summer, I kept things bright, added more stars, and went back in with a small Micron pen to add definition and detail to the leaves, grasses, and moon.

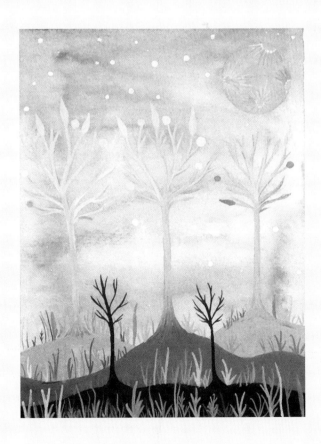

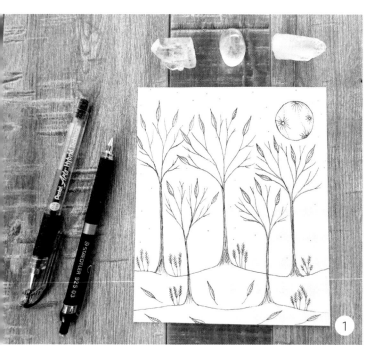

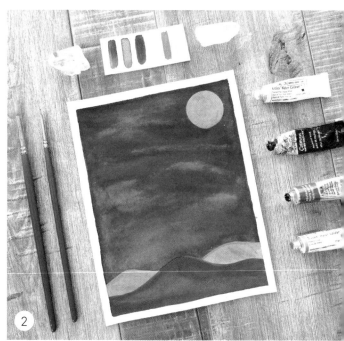

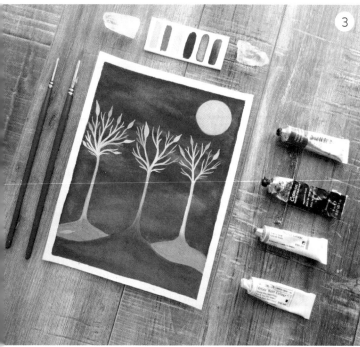

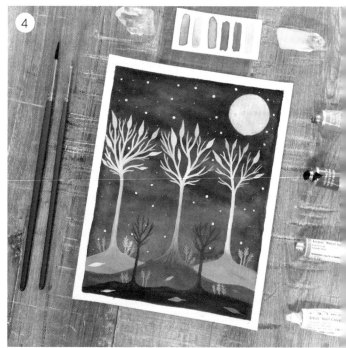

FALL VARIATION

1. Sketch out the composition, keeping in mind that you will be covering much of the painting with a dark wash and going back in with lighter tones. It helps to have the composition underneath as your guide.

2. Then go back in with a graded wash, from dark to light. I chose a Prussian blue mixed with a small amount of indigo. Add metallic gold into the wet, blue paint, which will dry and create a rich effect. Then let dry.

3. Once the sky layer has dried completely, bring in the landscape and stars with a 000 brush and a white gel pen.

4. For this stage add the final details, keeping things minimal and botanical elements less pronounced than in the previous spring and summer paintings.

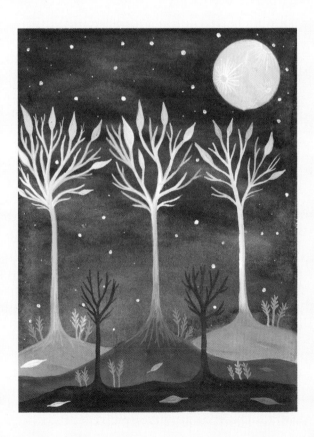

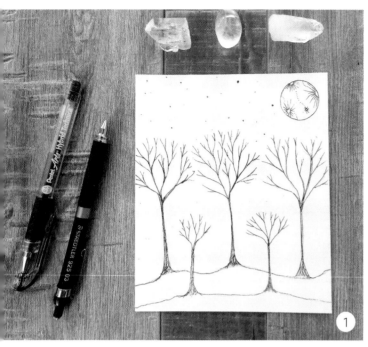

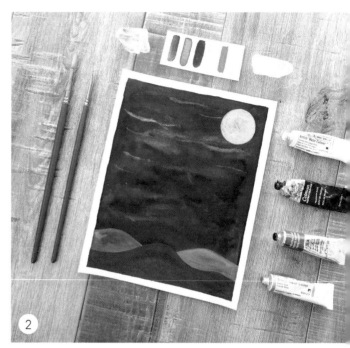

WINTER VARIATION

1. Begin with a sketch. For this winter season I kept the elements minimal and stark. There will be almost no botanical details except for the barren trees in the landscape.

2. Paint a graded wash from top to bottom and let dry. I used indigo and Payne's gray.

3. Go back in and start to bring the trees and mountains out with white paint and a 000 brush. Keep the mountains in deep shades of gray and the trees barren to capture winter.

4. For the final stage, add the last remaining details, such as stars, the smaller trees in the foreground and the fallen leaves.

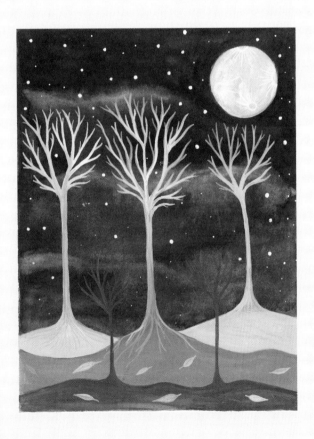

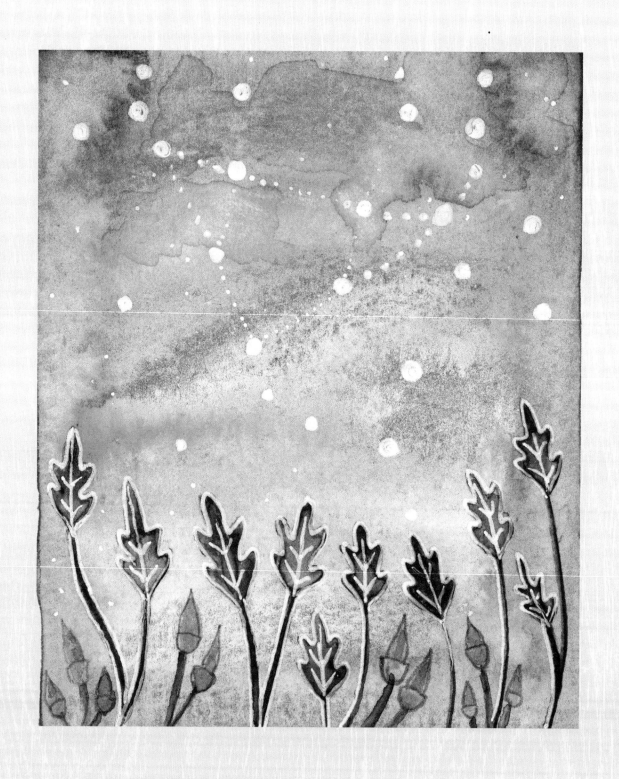

ACKNOWLEDGMENTS

Thank you to my husband, Matthew, for constantly supporting my creative dreams and for being a source of wisdom, guidance, and honesty in all of my artistic ventures. Thank you for staying up late with me while I worked on this project, and for being an amazing Dad to our kind and curious son.

To my dear Miles, you are a constant source of inspiration to me. There were times when you sat on my lap and watched me make the artwork for this book, or worked on your own amazing projects alongside me. Thank you for being part of my artistic process and for keeping me present and focused on my goals.

To my family, who has always been enthusiastic about my art-making and who has helped me and inspired my creative drive, even when I was starting out and had absolutely no idea what I was doing or where this path would lead.

To the amazing crew at Quarto, who are the most kind, dedicated, and knowledgeable people to work with, and who made this entire process a wonderful experience; it is an honor to have been a part of this book.

ABOUT THE AUTHORS

ELISE MAHAN was born in Arizona, but has lived much of her life in Northern California with her husband, Matthew, her son, Miles, and two sassy kitties. Elise creates paintings that are inspired by her love for astronomy, natural history, and her work as an early childhood educator. She uses a range of materials such as gouache, watercolor, graphite, walnut ink, and metallic pigments in her work. Each painting is a chance for her to draw upon ethereal and surreal elements that utilize and explore texture, color, and botanical elements that exist within the natural world. Elise aims to explore the connections between natural history and symbolism and how they relate to one another within art and society.

D.R. McELROY is the pen name of professional writer and editor Debra McElroy. Ms. McElroy holds a BS in Horticulture, and an MS in Environmental Resources. She is happiest writing in the service of environmental, conservation, and land remediation issues, as well as wildlife and indigenous plant populations. *Celestial Watercolor* is her first book for Quarto Publishing. She lives in Michigan with her patient husband and a neurotic rescue cat. She can be reached at her blog www.deescribe315.wordpress.com

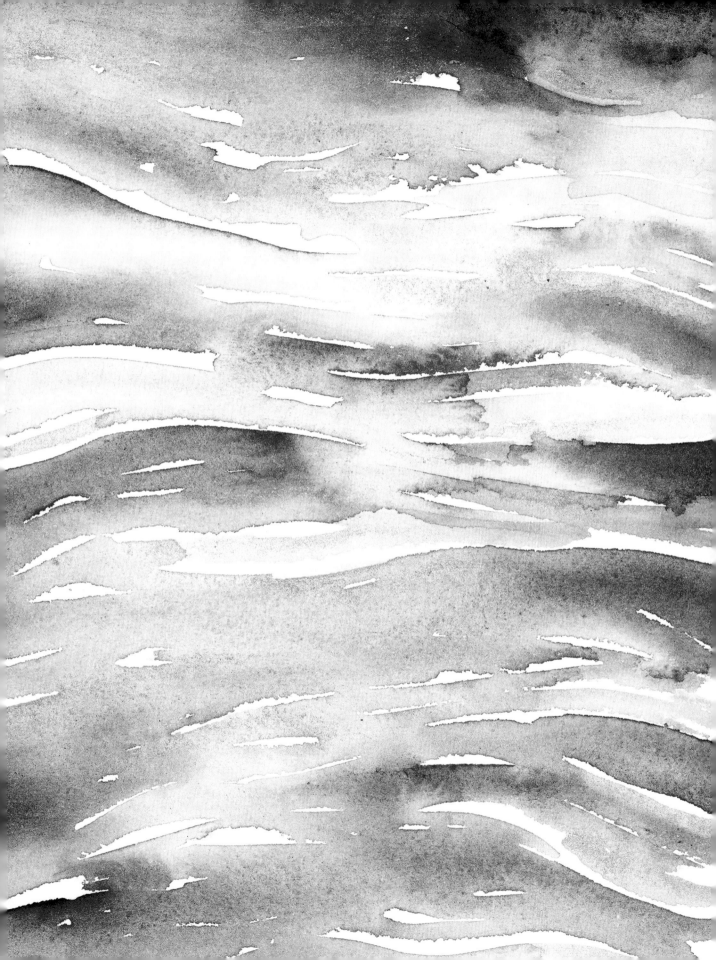

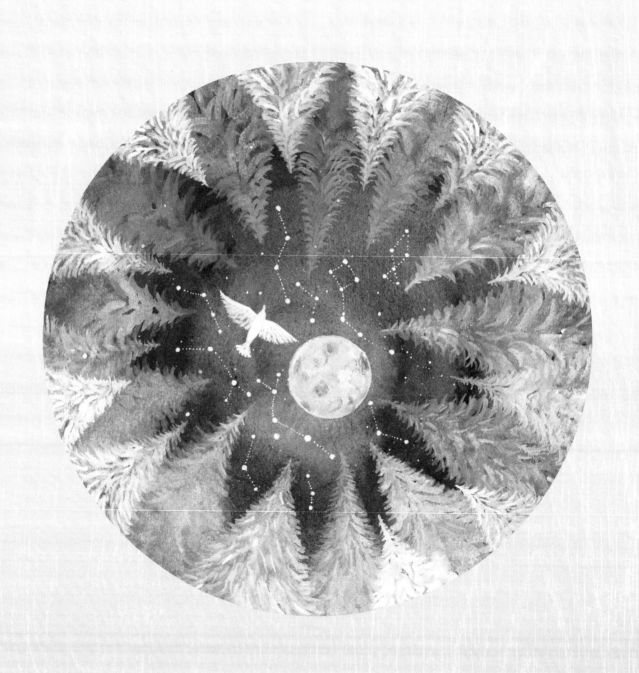